ABANDONED
UTAH

NICK BAGLEY

AMERICA
THROUGH TIME®
ADDING COLOR TO AMERICAN HISTORY

America Through Time is an imprint of Fonthill Media LLC
www.through-time.com
office@through-time.com

Published by Arcadia Publishing by arrangement with Fonthill Media LLC
For all general information, please contact Arcadia Publishing:
Telephone: 843-853-2070
Fax: 843-853-0044
E-mail: sales@arcadiapublishing.com
For customer service and orders:
Toll-Free 1-888-313-2665

www.arcadiapublishing.com

First published 2020

ISBN 978-1-63499-246-6

Typeset in Trade Gothic 10pt on 15pt
Printed and bound in England

CONTENTS

ACKNOWLEDGMENTS

Creating a book was much more work than I realized. From going on photo adventures to researching the history of each location, I would be lost without the individuals who supported me along the way. First, I would like to thank my wonderful girlfriend and adventure sidekick for tagging along on many of my trips. I realize that long drives and cold dark locations are not everyone's idea of fun. I am certain that on more than one occasion she would have much rather been in the warmth of our home than somewhere deep below the earth or in a partially collapsed building. I'd like to thank my good friend and fellow photographer, Jamie Thissen Betts, for helping me research and explore several of the locations touched on in this book. We both share the same passion for photography and constantly motivate each other to continue exploring and expanding our photographic universe. I would also like to thank my college professors, Michael Perez, Dan Hughes, and Steve Diehl. Not only did they teach me the fundamentals of photography but also inspired me to stick with my hobbies and encouraged me to never give up on my interests. I would like to thank my high school English teacher, Joan Leclaire. She helped motivate me at an early age and caused me to fall in love with the literary world. Her coursework touched on several aspects of publishing, many of which I used to help outline this book. I would like to thank the publishers, Fonthill Media, for reaching out to me and giving me the awesome opportunity to create this book. Their relaxed attitude and professional yet understanding demeanor gave me the support and freedom that I needed to create a truly unique work. By far the most influential people of my life are my parents. They have provided me with ultimate support since day one, and have helped to fuel my passion for adventure and lust for historical knowledge. Without them, I would not have been able to create the work that lies before you. From acquaintances to friends, old-timers, and youths, there are hundreds of other individuals too numerous to count that deserve my thanks. It has always been a dream of mine to be a published writer and photographer. I appreciate everyone who has helped me along the way.

INTRODUCTION

Photography has always been an interest of mine. I remember asking for cameras as a young child, always wanting to capture my friends and I as we partook in various adventures. My parents were able to provide me with small budget-friendly cameras, allowing my photographic interests to blossom into a full-blown passion. I was fascinated with abandoned structures and the history associated with them. I explored and photographed as many places as I could find located near my small town of Hammondsport, New York. As I got older, my enthusiasm grew, and I studied the art of imaging throughout college.

Although trained as a scientific photographer, I continued to explore and photograph abandoned locations throughout my college years. My senior capstone project was a culmination of the technical skills I had learned combined with my passion for history and desire to explore abandoned locations. I was able to receive permission from my professors to go about making a historical photo book of various abandoned locations throughout Rochester, New York.

After graduation, I moved to Utah to work as an ophthalmic photographer. I soon discovered that the state was full of abandoned mines, mills, ghost towns, and a plethora of other uniquely forgotten places. Not yet knowing anyone, I spent my weekends alone exploring the forgotten corners of the state. As I slowly made friends and connections, I began to find more and more locations to explore and have continued my obsession with the abandoned world that surrounds me.

From mills to mine shafts, gas stations to urban environments, the pages that follow showcase some of my favorite abandoned locations here in the state of Utah. Make sure that your camera batteries are charged and your memory cards are formatted and follow me into the dark, decaying world that is *Abandoned Utah*.

1

BAUER

We begin our adventure at Bauer. Located just south of Tooele, Bauer was first established in the early 1850s as a small mining town. In the 1920s, Bauer's main purpose was in the smelting of lead and silver ore. Operations continued until 1980 when the town's adhesive plant caught fire and burned to the ground (it smoldered for years). This fire caused all remaining operations to cease and residents evacuated, leaving Bauer abandoned. Structures remained here until the early 2000s when the majority of the buildings were bulldozed. Bauer used to be a private closed-off property, but no longer. If you are respectful of the site and accept the possible health hazards of the area, you are welcome to explore Bauer without harassment.

The first thing I noticed when I arrived in town was its proximity to the Toole dump. Because of this, trash litters almost every corner of this location. The remaining mine shafts in and around Bauer have filled with water, causing the ground on the surface to almost always be muddy. Depending on the season, parts of the town and old mining works fill with liquid, creating a pond of sorts. Although I have visited Bauer several times, I captured the majority of these images during the cold winter months. I have found this to be the best time of year to visit (depending on the weather of course) because the mud is mostly frozen, allowing for easy passage.

When entering the town, a DIY skatepark filled with rusty obstacles greets you on the right—no doubt an infection waiting to happen. Piles of decaying wood and rubble line what's left of the town's street grid. A few dugout basements and a leaning structure or two is all that remains of the town proper. After exploring the barren streets, I continue towards the ruins of the smelting/adhesive plant. A murder of crows hollers and harass me as I continue on my journey. Rousting them from their perch upon a dead tree, they squawk and scatter.

Partially crumbled structures jut out of the hillside, leaving pieces of concrete that look as if they were military bunkers or part of a castle's walls. Creative graffiti artists have turned them into unique works, giving Bauer a peerless personality all

of its own. Walking among the ruins, it looks as if the area was bombed. Feeling as if I have entered a post-apocalyptic world, I half expect zombies or raiders to overtake me at any moment. Overwhelming my senses, I take picture after picture, knowing it's impossible to accurately represent Bauer in a photograph. All I can do is preserve it how I perceive it, creating my own unique photographic record of the places I've been.

For readers who wish to explore Bauer, please note that this area is considered to be toxic due to the dumping of chemicals that were a by-product of mining operations. The fire that destroyed the adhesive factory didn't help things either, releasing toxic chemicals into the air. If you take the proper safety precautions and keep your visit relatively short, you can safely explore Bauer despite its noxious past.

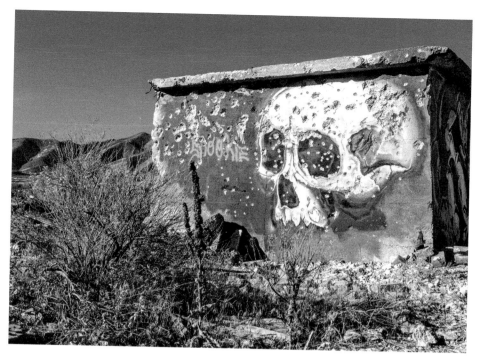

Creative artwork turns the abandoned remains of Bauer into a post-apocalyptic landscape. Bullet holes, shell casings, and targets litter the area.

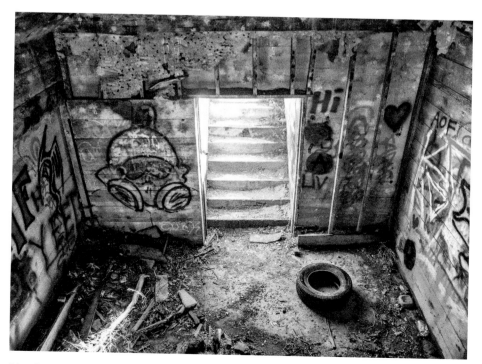

What little remains of the buildings that once stood here has been turned into hangouts and safe harbor for stragglers and vagrants.

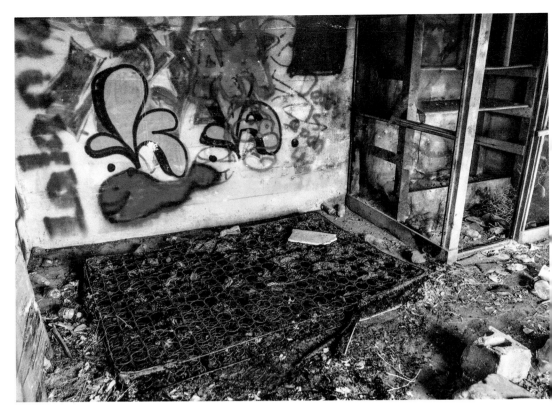

I've slept in worse places. Well, maybe not.

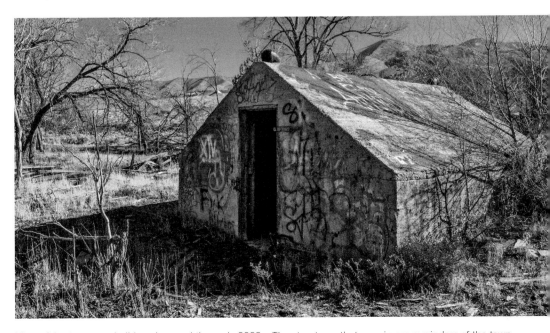

Most of the town was bulldozed around the early 2000s. The structures that remain are reminders of the town that once thrived here.

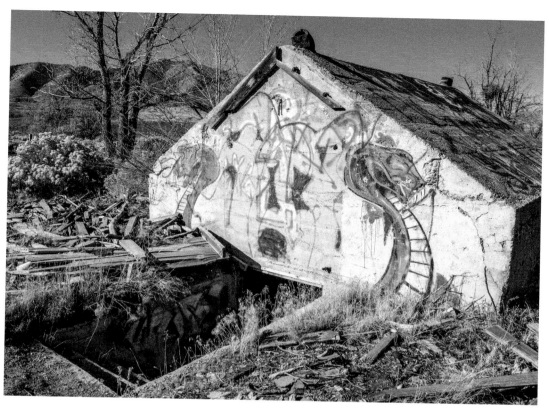

Entrance to the snake's lair.

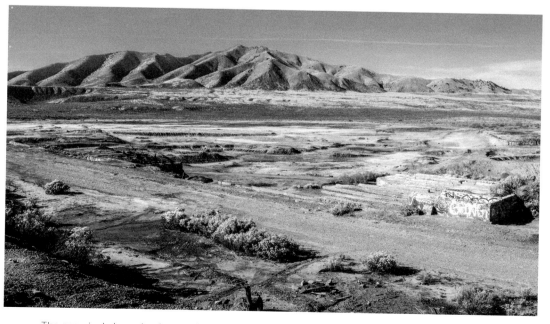

The seemingly lunar landscape that surrounds Bauer provides a stunning backdrop. Be wary, as the soil underneath my feet contains toxins from the resin plant fire that burned for several years.

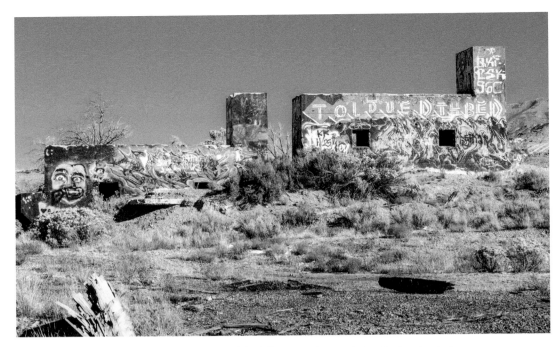

Artwork adds character to every structure here, giving it its own unique and visually stunning look.

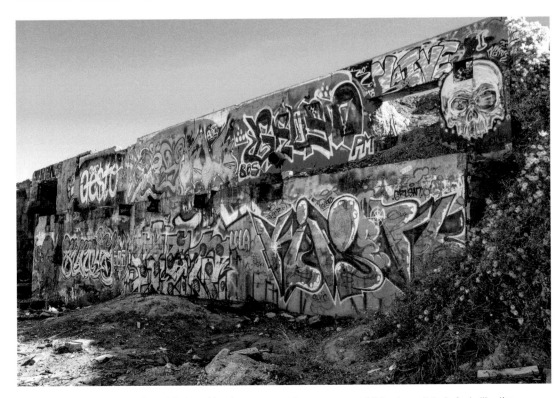

I keep imagining a horde of zombie is waiting for me around every corner of this place. It truly feels like I'm wandering through another world.

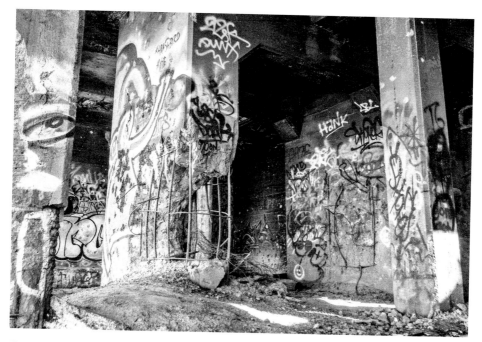

The all-seeing eye watches me as I wander amongst the ruins.

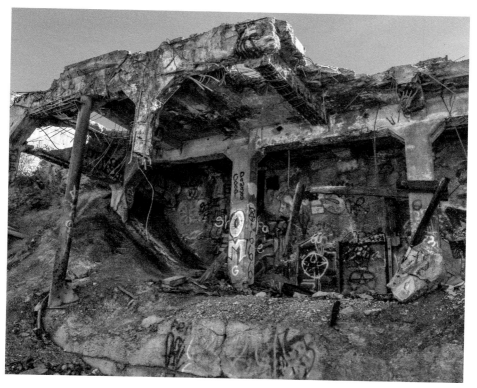

If I didn't know the history behind it, I'd be inclined to believe that this was once a war zone or a weapons testing site for the military. It's no wonder why a paintball tournament was once held here.

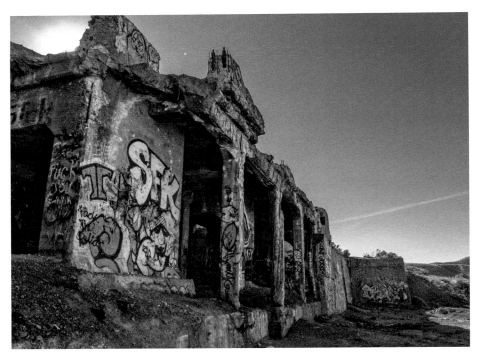

Slowly crumbling from the unrelenting forces of gravity, structures break apart piece by piece. Nothing is immune to the ravages of time.

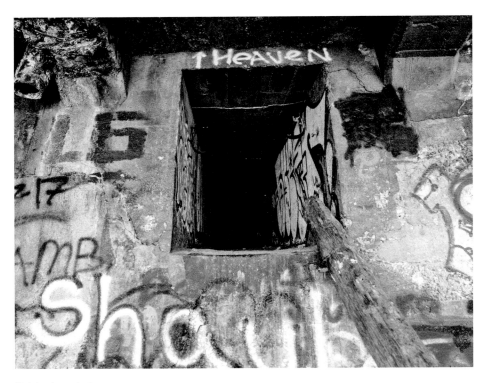

Quickest way to heaven.

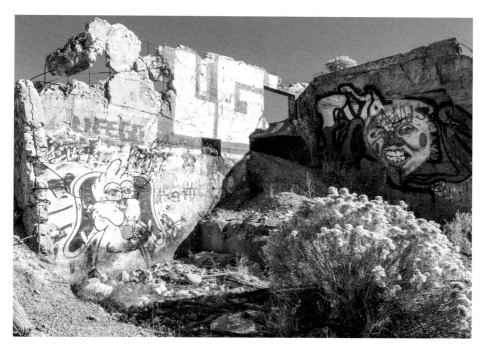

The dog seems unafraid of the menacing face in the corner. Perhaps the tattoo on the jester's head has defused the situation.

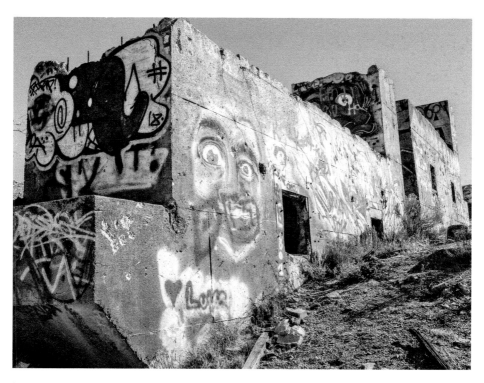

Reminding me of a World War II era bunker, these concrete walls have held up well against the intense unrelenting forces of nature.

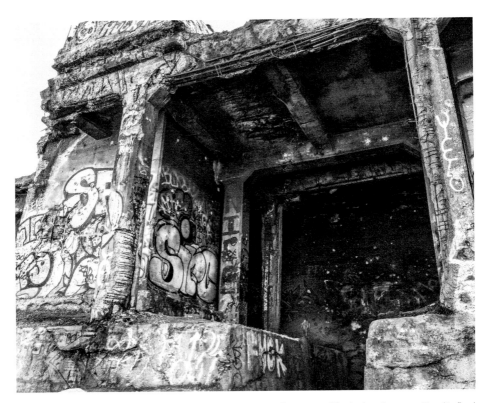

Towering pillars loom over me. A once great structure now lies tattered in destruction, awaiting its final days here on earth.

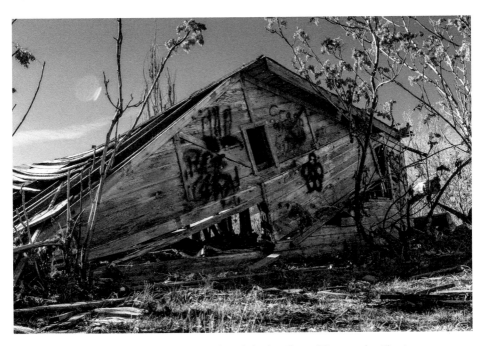

Few wood structures remain here, leaving rotting skeletal outlines of the once bustling town.

2

MODENA

Continuing on our adventure, we head southwest towards the Nevada border. Our destination is a small railroad town called Modena. Located approximately 9 miles from said border, Modena acted as a stopping point for the railroad on its way in and out of Nevada. In the early 1900s, Brigham J. Lund, E. M. Brown, and Jose Price started a freight company here. They primarily shipped freight to and from St. George, Utah; Pioche, and Delmar, Nevada. In 1903, Lund took control of the business by buying out his partners. He renamed the operation to B. J. Lund and Company. One of the last remaining structures (the hotel) still bears his name.

On our way to Modena, we stumbled across a unique abandoned gas station not too far away from our original destination. An old car remains parked out front, making it feel as if the gas station is still open. I imagine the owner is inside buying some snacks or paying for fuel. Make no mistake however, for this location is most definitely abandoned. Old rusted-out gas pumps endure the endless passage of time. When peering through the window, it looks as if merchandise still rests on the convenient store's shelves just waiting to be bought. Given its unfrequented location, it's no wonder it went out of business.

After driving for miles along barren land, a fork in the road signifies that we are close to our destination. Modena seems to appear out of the desert like an existing mirage that promises nothing but decay. Trains still run through Modena on their way to and from Nevada, but they have not stopped here in many decades. A few residents remain so be cautious and respectful when exploring the ruins. Nestled right alongside the tracks, the town had built a direct relationship to the railroad like veins helping to nourish and oxygenate it.

The General Merchandising and Hotel is the grandest remaining structure in the town. Looming over the area, its rotting bones have reached a state of collapse. Trees have begun to grow near and into the building, creating an advanced stage of decay. Keep out signs are dotted all over the building not for fear of trespassers,

but rather for fear of safety. A sudden cave-in or floor collapse could severely injure and possibly kill us while we're inside. We can't resist braving the danger, for we know that this hotel will soon collapse, effectively destroying history itself. I must photograph it before it's gone forever.

Once inside, the first thing I noticed is the stairs. Looking as if they belong in a ghost story, the rotting steps remain. As I ascend them, I begin to feel strange. I start to wonder about the men and women who once frequented this hotel. How many travelers, railroad workers, and ordinary citizens spent the night within these walls or bought merchandise from the general store? I feel I am truly in my element; I am walking in the footsteps of history, doing my best to preserve what is left before it is gone forever.

While the stairs remain, once I reached the top, I could go no further. The entire floor had caved in, a gloomy foreshadowing of what will soon consume the entire structure. I contemplated going further, feeling the creaking floorboards beneath my feet. Ultimately, I decided my weight would be too much for the old floor to handle. I take a few photographs documenting the collapse and continue back down the stairs.

Dark and disheveled hallways line the first floor connecting to several rooms. The floor itself is covered in rubble. I feel glass crush beneath my feet as I continue my exploration through the despondent corridors. Near the center of the house lies a door, an entrance into the dark world of the hotel's basement. Descending the steps into the crepuscular space, I gingerly tread into the gloom, making sure I have safe footing. Once at the bottom, I fire my flash in all directions illuminating every corner. Few traces of the long-gone inhabitants remain, but I keep searching. I find cans, rusted and damaged tools, and the old furnace that once kept the hotel warm.

Few places remain that are as old and isolated as Modena. Given its current state of decay, the remnants will soon collapse and drift away into history. Photo trips like these are the reason I initially became enthralled in this type of photography. I am a strong believer in preserving the past and I feel that my photos will in some way create a record of what once was. I'm leaving Modena for now, but I can assure you, I will be back before its inevitable demise.

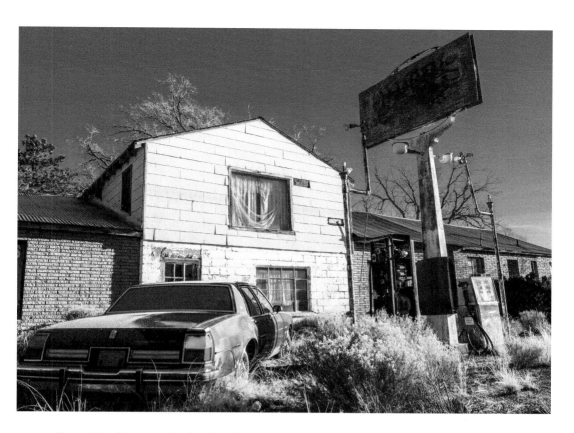

Above: I stumbled upon this abandoned gas station while on a trip with friend and fellow photographer, Jamie Thissen Betts. The car makes it seem as if someone had stopped for gas and just walked away.

Right: I've always been fascinated by old gas pumps; I wonder how much it cost to fill up when this pump was in operation?

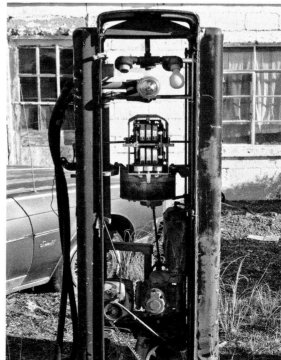

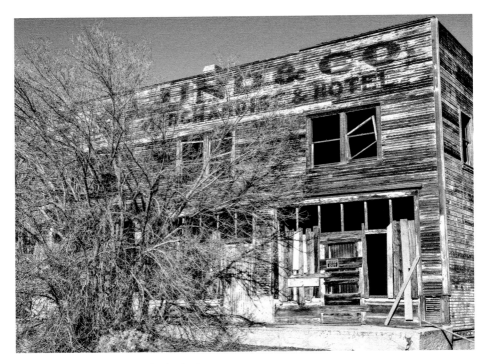

Keep out? All the rooms must be booked.

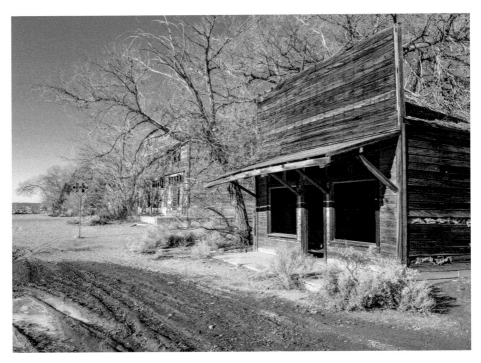

While the train still travels through town, it has not stopped here in years. The local economy has been starved of business, leaving the hotel and a few other buildings to remain eternally waiting alongside the tracks.

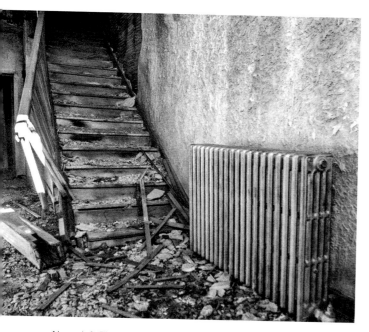
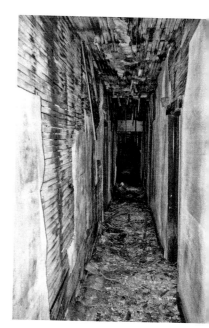

Above left: These stairs feel as rickety as they look. Oh well, there's only one way up!

Above right: My weight causes the floor to moan and groan as I carefully make my way down the gloomy hallway.

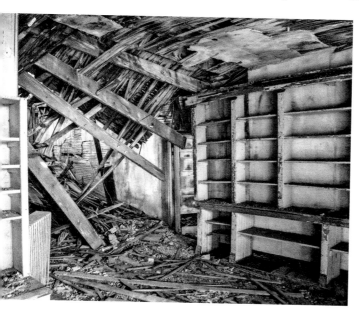
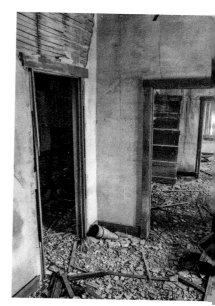

Above left: Time hardened and tired of standing, the ceiling has begun to collapse. Not much time left for this location.

Above right: Left or right? One leads to decay, the other to destruction.

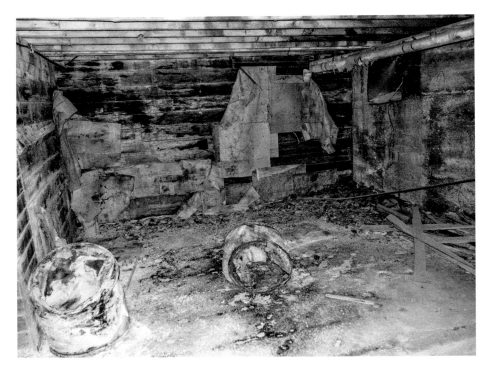

Beneath the earth lies the dark damp basement where old tools and buckets still remain.

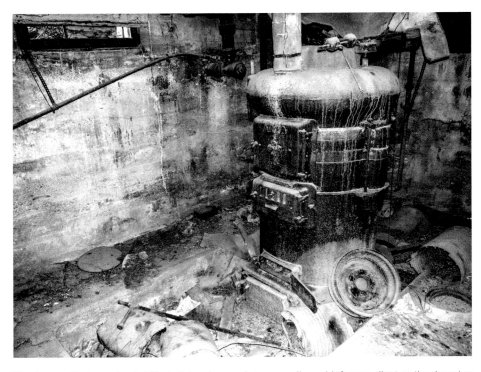

The furnace that once heated the hotel and general store now lies cold, forever silent as the decaying building slowly buries it.

3

MAMMOTH

Heading back north, my next destination was once a booming mine town. Mammoth, Utah, came into being in 1870, when silver, gold, and other precious ore was discovered in the surrounding mountains. One of the most hazardous aspects of Mammoth was and is its isolation and harsh living/ working environment. Although water was plentiful for use in mining operations, it was deemed too contaminated for drinking. In turn, the town's clean water supply had to be trucked in and residents were charged 10 cents per gallon.

Despite these less than ideal conditions, Mammoth's population exploded reaching its peak of roughly 3,000 people between 1900 and 1910. Both men and women were attracted to the town longing to strike it rich in one form or another. At its height, the town had four hotels, a school, general stores, and saloons, among other businesses, allowing for ample employment for those not working in the mines. Unfortunately for Mammoth, the mining boom and influx of people it brought with it would not last long. By the late 1920s, the majority of mining operations had seized, leaving just 750 remaining residents. A few smaller mines still operated but the town itself ultimately died leading to its disincorporation in 1929.

These days, Mammoth bears little resemblance to the once-booming town of its past. The few people who live here either work within the small remaining mining operations or commute. The hotels, stores, school, and other structures are long gone, leaving little evidence of the once great town. While a few old homes remain within the original town limits, the most interesting remnants can be discovered in the mountainside, hidden to the untrained eye.

I didn't know what to expect when I first visited Mammoth. I had researched the area and knew of its past but was unsure of the extent of what remained. Being under-whelmed by the town itself, I noticed mine trailings dotting the mountainside. Always up for an adventure, my friend and I decided to hike towards them, making sure to avoid private property along the way. Steep, rough, and rocky terrain greeted us. But as we climbed higher up the mountainside, clear evidence of mining began to appear.

At first, the only evidence that was apparent to us was a few piles of rotting timbers and a vast assortment of rusted nails and cans. We could see where the old road used to be, now hardly distinguishable from the mountainside. So many years had passed since its last use. Weathered and worn by time, it had almost fully returned into the mountain. We continued following the road, hoping it would lead us to a mine shaft or a structure of some sort. A short yet steep hike brought us to a wonderfully hidden location that just a few hours before was unknown to us. My blood started pumping as I began to explore and photograph this exciting place.

A grand abandoned mining structure greeted me. Upon exploration, I found it to be in an advanced state of decay. While most of its walls remained, the ceiling had since fallen victim to the elements, no doubt being torn off after years of isolation and exposure to the wrath of nature. Walking among the remains, I feel as if I am in a church or some grand structure with vaulted ceilings. Blue skies above me create an exciting contrast to the muted colors of the rubble. The ever-present wind causes support beams and loose metals to creek and moan, breaking the eerie silence that often accompanies me at places such as these.

Throughout the structure, evidence of everyday mining life endures. Bins remain labeled, waiting for their assigned tools and parts to be placed within. A chalkboard bears the writing of a long-forgotten miner reminding those to be sure to shut off the shower upon leaving. Broken pieces of heavy machinery cover the floor weakened by the ceaseless ravages of mother nature. Mammoth remains to this day as one of my favorite surprise locations. I never intended to explore this particular building, reminding me that the best locations are often those I didn't plan for.

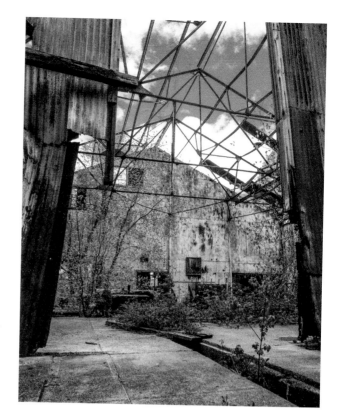

Right: With the roof completely gone, this mining structure has decayed at a rapid rate, due to being exposed to the harsh elements of nature.

Below: Labels still clearly indicate the proper location to find and store machinery parts.

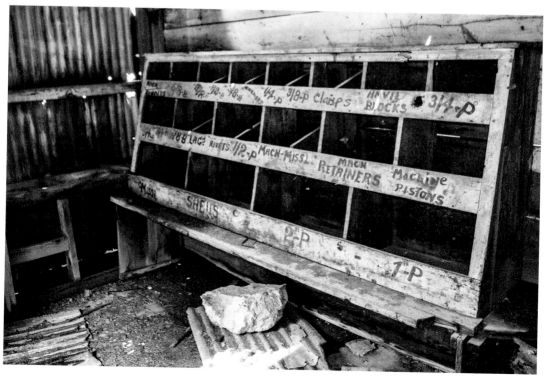

Left: Please remember to close the door upon leaving

Below: Broken bits of mining machinery litter the floor. What was once a loud and vibrant workspace now lies motionless and silent. Resting in death.

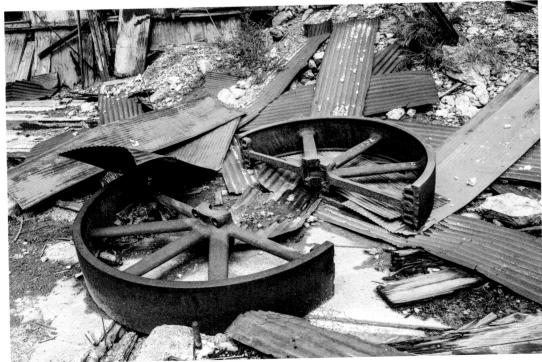

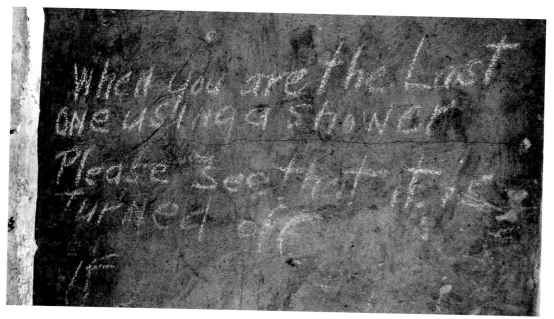

I was sure to turn the shower off as soon as I left!

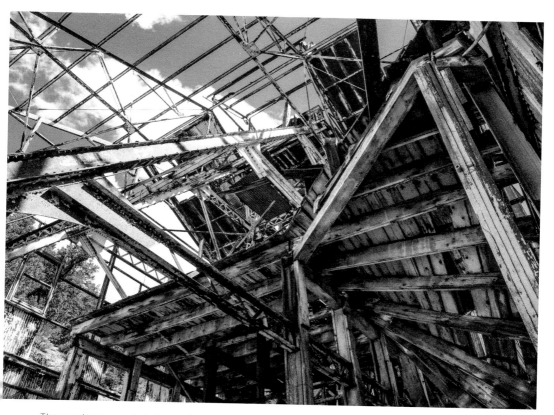

The wood warps and strains against the weight of the remaining building. It's almost as if it's twisting its way back down towards earth, losing its life-long battle against gravity.

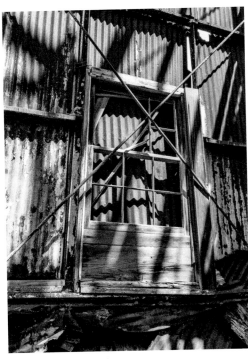

Left: Well that can't be the way out, can it?

Below: This could be the last time I see this structure. I pause to take one final photo, unknowingly capturing my friend Jamie descending the rusty stairs.

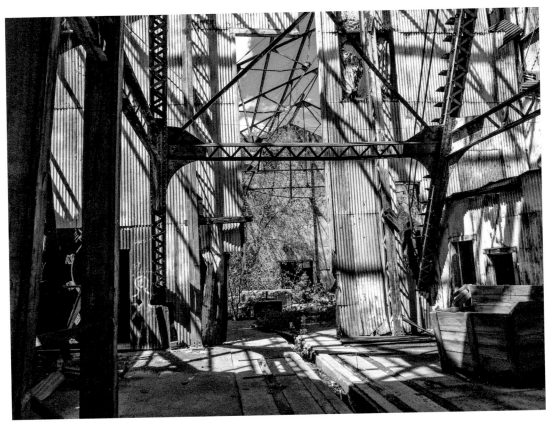

4

JACOB CITY AND SILVER FORK

Our journey takes us to yet another remote mining operation, Jacob City. Mining surveys began in the area around 1865, providing positive results for silver. Ten years on and the city had roughly 300 permanent residents. Saloons, cabins, a brothel, and many other shops existed nestled between the canyon walls. When the mine was at its peak production levels, it was bringing in nearly $60,000 a month. When adjusted for inflation, that equals out to approximately $994,809.86. Mining operations thrived until a fissure hidden deep within the mountain halted all progress. Never able to find the vein of silver again, the mine went bankrupt and ceased operations.

The road up to Jacob City has turned into quite the adventure within itself. Several miles of steep, poorly maintained roads swerve and snake their way up Dry Canyon. Be warned, the name Dry Canyon can be deceiving. On my first trip up the mountain, I encountered washed-out roads and lots of mud. My lifted Xterra didn't seem to mind though, and I slowly ascended the mountainside. Parts of the road take you out on the edge of a cliff, providing a stunning view of the surrounding mountains. Because of the rainfall, steep parts of the road have turned into mini waterfalls, adding to the dreary ambiance of the location.

While the road can be a bit hazardous at times, the conditions are relatively mild compared to what the miners faced. The technology of today grants me passage with relative ease, a luxury the miners did not have. The logistics of transporting all the resources needed to build and support an entire town in a location as isolated as this one boggles the mind. It seems the human spirit will stop at nothing when presented with an opportunity to strike it rich, a testament to the willpower of mankind (whether good or bad, I'll let you decide.)

Not even a quarter-mile away from the townsite, the road becomes impassable. The final stretch has been completely washed out, leaving a gap in the path that ends off the side of a cliff face. I park my vehicle, gear up, and hike down towards the mine site. Not much remains of the townsite on the surface. Piles of decaying

lumber now lie in place of the buildings that once stood. A few leftover beams still stand, representing the location of large mining structures that once stood here. Evidence of off-roading and camping is everywhere. Shotgun shells litter the ground from hunters and recreational target shooters who now frequent the spot. Even in the rain, the encircling landscape gazes at me, beckoning me to explore the secrets contained hidden deep within the rock.

I walk amongst the trailings sifting through the old piles of junk that litter the flattened townsite, looking for unique links to the past. Cans, pieces of a stove, parts of shoes, and many other objects litter the area. Scanning the countryside, I notice signs of a possible mine entrance. A hole appears to be protruding out of the earth, hinting a possible entrance. Wooden support beams make themselves visible as I get close to the entrance. I get closer and closer hoping that the entrance had not been filled in or blocked off by metal bars. Alas, the entrance is open! I briefly pause to open my backpack and prepare to enter the darkness, checking my flashlight and preparing my camera for the cold, harsh environment.

Before I continue into the first mine tunnels of this book, I feel it is important for the reader to understand the hazards these locations pose. Cave-ins, sketchy ladders, old rotten beams, collapsed floors, insects, and bats are just a few of the challenges I face when entering an old mine. But the most dangerous aspect of photographing an abandoned mine tunnel is the possibility of passing out from encountering poisonous gases. After drilling into the earth miners may have hit pockets of poisonous gas locked away within the mountain. The easiest way to detect this is to bring a lighter. If you flick the lighter on and it burns you know there is enough oxygen and it is safe to continue. If you start to feel lightheaded and the lighter won't ignite, that means you do not have enough oxygen and you need to evacuate immediately. Keep in mind, however, that statistically speaking more accidents occur not from being inside the mine shaft itself but rather driving over them causing them to collapse, possibly swallowing the vehicle whole. These risks don't scare me, but rather motivate me to explore more. It's a rush in its own right knowing that danger is ahead of me. Down into the darkness, I go.

Wooden beams attempt to hold back the forces of nature as the rock walls press against them. Most of the remaining supports are wet and spongy to the touch not giving much in the way of real support. I follow the ore cart rails as they point the way ahead. Several forks and turns can easily confuse explorers. I have heard horror stories of adventurers like myself getting turned around and lost inside the mountain. Most mine tunnels I've explored have already been mapped out and marked by explorers before me, giving direction to the exit and the safest way out. I find an entire section of the tunnel rotting away. Mine tracks still rest on the man-made

wooden floor that used to support the ore carts as they passed overhead. The cold, dark, and wet environment has caused many of the structures to collapse, resulting in a mushy pile of rotten wood fibers.

Even in a location as isolated as this, I still find graffiti. Names and dates going back decades can be found covering the walls. I once found a name dating back to the early 1900s showing that the drive to explore seems to be an involuntary desire hiding inside all of us. Twist and turns take me deeper into the depths of the mountain. Some tunnels have completely caved in, leaving a mess of rotten timbers, rusted metal supports, huge boulders, and crumbled walls. I snap photo after photo knowing that soon this entire place may collapse forever, erasing the evidence of what once occurred here.

Finding tubs, cans, rusted tobacco tins, ladders, mine carts, and various other objects that were left behind by the miners, I continue to explore and discover the secrets this mine tunnel still contains. Most of the items I find are worn away, leaving little evidence of what the objects once were or contained. Over the years, I have learned to keep my eyes open, knowing every nook and cranny of a mine tunnel can contain objects or writings that help me to decode the past. I have crawled through narrow caved-in spaces allowing access to open chambers beyond. I have climbed up and down 100-year-old wooden ladders in hopes of finding a new section of tunnel granting me access to places that have gone unexplored since the mines were in operation.

There is something genuinely unique about mine tunnel exploration and photography. Not many photographers or adventurers dare to brave the mines due to the inherent danger of them. People like me thrive on this danger. I get a rush or natural high from tempting the darkness of these tunnels. Knowing that few people have gone before me makes me want to explore even more. In a way, I believe exploring these places grants me access to the darker parts of my mind, unlocking a unique form of creativity. Both my writings and images reflect this as I create a unique photographic view of the forgotten world. For every mile I wander beneath the earth, I feel that my thirst for adventure grows. Using my photography as a vessel for adventure, I have unlocked a new obsession, a passion for exploring the unknown that inspires me to search out the darkest forgotten places here in Utah.

The walls of the mountainside have begun to reclaim the man-made tunnels. Water seeps in through the cracks in the walls, accelerating cave-ins and collapses. Some sections of the mine have completely filled with mud while others remain in a decent or partially filled-in state. Theoretically speaking, at any second the earth could shift, causing me to be trapped forever deep within the mountain. The unseasoned mine explorer may be intimidated by the collapsing state of the tunnels, but not I.

Having explored many mine tunnels over the years I have grown accustomed to the hazards and now calmly walk through the collapsing corridors contained within the earth. These dangers which once hampered my expeditions now serve to fuel my thirst for adventure. Knowing each mine I enter could be my last, I take my time exploring, attempting to unlock all the hidden secrets it may contain.

Exploring a mine such as this can be just as frustrating as it is exciting. Many parts of the mine will forever be closed and locked away by the earth. Entire sections of the mine now lie blocked off, locking away their secrets for eternity. What often drives me crazy is the fact that I may be standing above or below some grand hidden chamber or artifact and never know it. Both natural and man-induced cave-ins permanently block off entire sections of the mine leaving a network of tunnels to be entombed within the earth. Who knows what still resides in these tunnels. A possible plethora of artifacts may still exist. Items that may be priceless in terms of historical or personal significance will forever be buried, never to be seen again.

Our next destination requires us to journey up Big Cottonwood Canyon. Now popularized because of the ski resorts bringing thousands of visitors to the canyons each year, the canyon itself had humble beginnings. As the Mormons began to flock to Salt Lake City in the 1840s, the number of houses and merchant buildings began to skyrocket, causing an insatiable hunger for lumber. The Mormon settlers began to explore higher and higher into the surrounding mountains in search of more lumber. At first, the lumber industry caused small seasonal lumber operations to spring up. At the time, there was little interest in mining, leaving Big Cottonwood canyon to be unexplored in terms of geological resources. The lumber workers explored and named the geography of the canyon, unknowingly laying the groundwork for future mining operations

In the 1860s, General Patrick E. Connor spearheaded an effort to begin mining operations in the Big Cottonwood Canyon area. Connor was the U.S. military commander for Utah at the time and he used his military and political position to carry out exploratory mining operations within the canyon. By 1863, soldiers, townsfolk, and prospectors all began exploring the canyon, hoping to strike it rich. Even women got in on the rush which went against the social norms of the time. Mrs. Robert K. Reid for example, the wife of the surgeon stationed at Fort Douglas, joined in on the rush and began to search for precious minerals as well.

With promising results from Connor's early exploratory expeditions, he urged the government to grant him funds and supplies to further explore the mining possibilities of the canyon. His request was granted and his troops set up camp. Soon, silver ore was discovered, requiring Connor and his colleagues to create their own rules and regulations regarding federal mining. As word spread of the discovery, miners from

all over began paying attention to the area, hoping it would be the next big mining boom. At this point in American history, however, the Civil War was still raging. The majority of the United States population was in one way or another in the midst of a brutal war, preventing them from rushing out to Utah or other mining finds. When the war ended in April of 1865, both men and women were finally able to focus on something other than war. Many of them turned to the mines.

It was at this point when mining operations picked up in the Big and Little Cottonwood Canyons. Silas Braine and H. Poole, who were both operating under the New York and Utah prospecting company, laid claims in the area hoping to strike the motherload and jumpstart a new gold and silver rush right here in Utah. Investors from the east supplied the funds needed to develop the mines. Unfortunately for all those involved, they never really panned out and eventually the operations in both canyons stopped. While all this was occurring, places like the Silver Fork Lodge sprung up and helped to supply those working in the canyons.

Located about three-quarters of the way up Big Cottonwood Canyon at roughly 8,000 feet, Silver Fork Lodge stands as a reminder of the once-great mining past. Its name was derived from the clean water source that supplied the area. Silver Fork was once the largest a tent city in the area, supplying the miners with the infrastructure that they needed to work and live in the harsh mountain environment. In its prime, around 2,500 people called this area home. With eight saloons, multiple stores, and an LDS ward, residents had plenty to entertain themselves in their downtime.

By the late 1880s, the mining operations had already begun to wind down. The land around the Silver Fork area had begun to shift from mining to homesteading. Sheep and cattle herders began to take the area over as the mining operations slowed. A few mines continued to operate into the mid-1900s. The final mine halted operations sometime in the 1950s, thus ending the major mining operations in the area. A small independent mine operated well into the 1960s. The miner had been blinded in an accident, thus granting him the nickname of "the blind miner."

Today, the area in and around Silver Fork is a hotspot for those seeking outdoor fun and a break from the hustle and bustle of Salt Lake City. This area is now home to about 120 residents, none of which work in the long-closed mines. Two ski resorts, Brighton and Solitude, keep people coming to the canyon in the winter. In the summertime, many trails around the area weave in and out of the old mining properties. Hunters, mountain bikers, and hikers all frequent this location to take in the beautiful views of the Silver Fork area. The Silver Fork Lodge itself still resides in its original location. Its appearance, however, is quite different, having been modernized to keep up with today's standards. Rather than being a general store like it used to be, it now serves tourists and locals food inspired by the area's

mining past, as well as housing weary travelers in its appropriately themed rooms.

Original wood beams from the mines were used to construct the dining room ceiling. Once inside the building, an old worn photograph from the original general store can be viewed in the dining area. Glass tiles from the 1940s still decorate the bar and many other historical treasures can be found hidden throughout the lodge. I frequent this lodge whenever I am in the area, enjoying its old charm and yummy food. I use the Silver Fork Lodge as a jumping-off point for my mining explorations in the canyon. For years I had no idea that any open mine shafts still existed in the area until one fateful day.

I was hiking up a new trail and stumbled across evidence off old mining operations. As usual, I began to find bits and pieces of old metal and rotting piles of wood. As I climbed higher up the trail, I could see mine tailings indicating that an entrance was nearby. At first, it looked as if all the entrances had been filled in either by Mother Nature or humans. I continued to explore the area, finding more rusted pieces of metal and wood. Stopping to catch my breath, I turned around and spotted a small hole in the earth behind me hardly noticeable to the untrained eye. Upon further examination of the hole, I discovered it opened up into a large mine shaft with support beams and tracks running through it. Once again, I prepared to enter the tunnel, preparing my gear for the dark unforgiving world hidden deep within the earth.

I slipped through the small hole between the rocks, feeling as if I may get stuck. The earth had almost filled in the entrance, completely leaving only a small crack for me to squeeze my body through. Once through the crack, however, the tunnel opened up, revealing a well-preserved mine. The first thing I noticed about this particular mine was that the ceilings were taller than the majority of the mines I had been in before. At 6'2", my neck really appreciated the extra headroom. A few bits of graffiti remained from past explorers with trash and beer cans which were strewn about as well. I like to analyze the dates on some pieces of trash to give me a rough idea of the last time the mine had been explored. In this particular mine, the date on an old beer stated 1984. Even though this date is well after the mining operations seized, I still find it interesting because it shows me that even to this day only a few people have explored it.

Several tunnels split off the main shaft. I thoroughly explore every one of them, finding support beams, metal barrels, nails, pieces of lights, and many other rusted and rotted relics. Each of these offshoot tunnels concludes in a dead end. Continuing down the main shaft, I come across a central room filled with rail tracks, ladders, and a partially rotten wooden structure. This structure appears to be some sort of loading apparatus with the mine tracks stopping directly underneath. It looks as if

that at one point, the tracks continued on, but now end in a mound of earth where a fatal cave-in has forever sealed the remainder of the tunnel. I follow the main shaft for a few hundred feet, where it ultimately ends in a solid rock wall. I can see where holes have been drilled into the wall, indicating that the original plan was to continue the tunnel. It looks as if miners had to stop operations abruptly, leaving their plans of expansion behind many years ago. While this mine is relatively small compared to others I have explored, it's in very good shape, making it one of the safer mines I frequent.

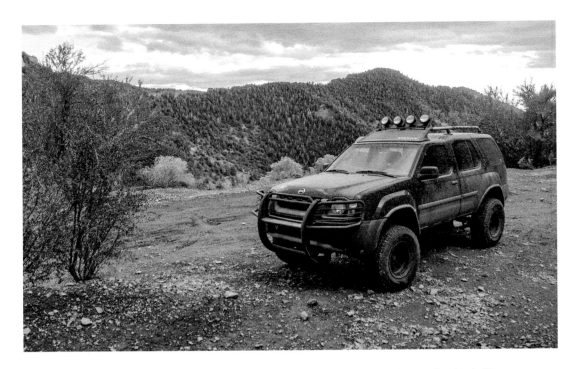

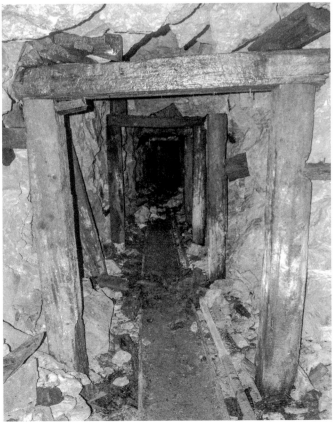

Above: The road to Jacob City can be rough and unforgiving. Having a high clearance vehicle can make all the difference. Time after time, my trusty Xterra (nicknamed the beast) has safely transported us up the old mine roads.

Left: Support beams attempt to hold back the earth.

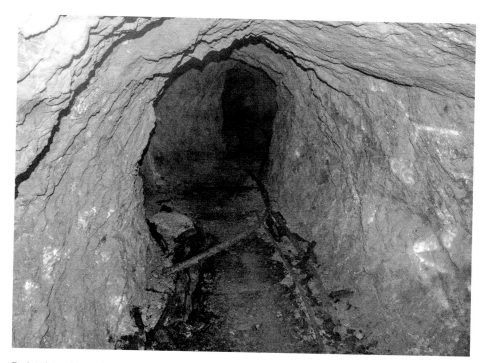

Each twist and turn gives me a boost of excitement. I never know what's awaiting me around the next corner.

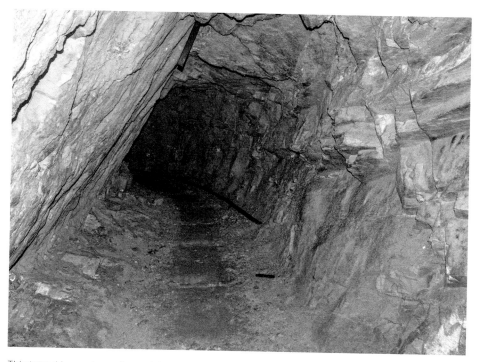

This tunnel has a sheer diagonal face on its left side. The miners must have avoided drilling through it because of the harder rock.

It's easy to get lost in the seemingly endless labyrinth of dead ends and cave-ins. Markings on the walls from explorers long ago help to keep me on the right path.

Graffiti is everywhere, even deep within the earth.

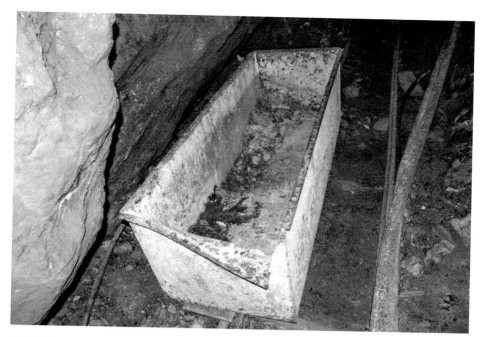

Most of the tunnels have had the majority of their equipment removed, but occasionally, I hit the jackpot. Here is a rusted and decaying bin that was most likely used to transport ore and waste out of the tunnel and up to the surface.

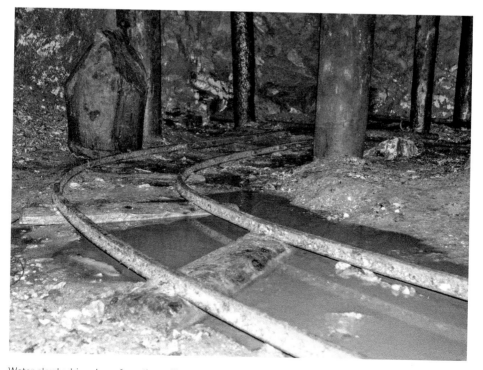

Water slowly drips down from the ceiling, creating puddles that slowly assist in the erosion of the man-made objects that are still entombed within the mines.

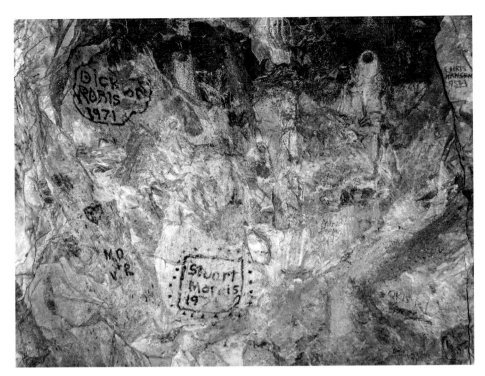

For decades, mines have lured like-minded explorers into their midst. Pictured here is graffiti from long ago.

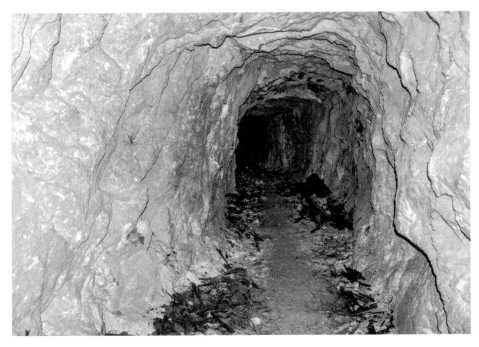

Sharp jagged rocks line the ceilings and walls of the tunnels. A hard hat may come in handy in places such as these.

Collapsed support beams lie on the floor, soft and spongy from the moist cave environment.

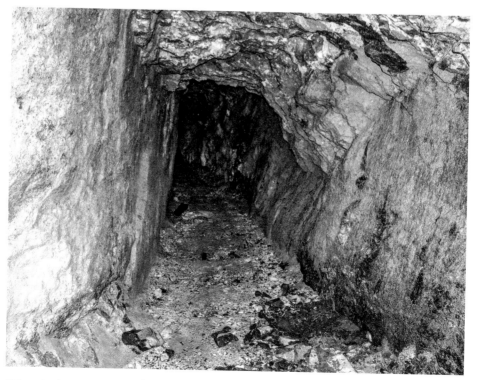

Different color rocks and minerals can be seen here. These differences helped miners to determine if an area was worth mining or not.

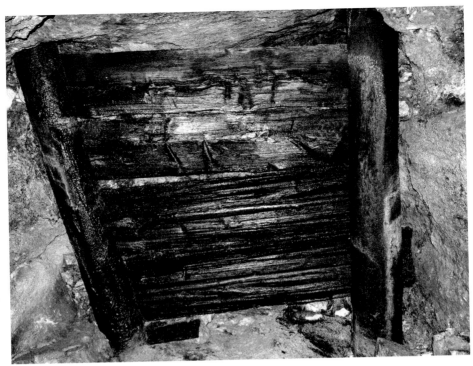

Although decaying and wet, this support wall still holds strong, doomed to hold up the mountainside until its inevitable and total decay.

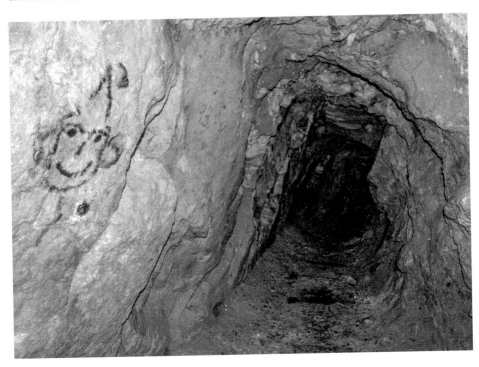

Be careful, goblins inhabit some of these tunnels, even if they are imaginary.

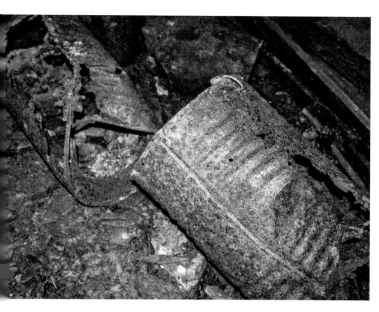
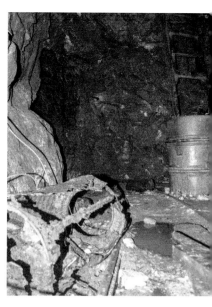

Above left: Rotting remains turn into historical markers, soon to fully succumb to the harsh realities of an underground environment.

Above right: I highly doubt this was used as a real ladder when the mine was in operation. No sane person would ascend a ladder resting on a barrel, would they?

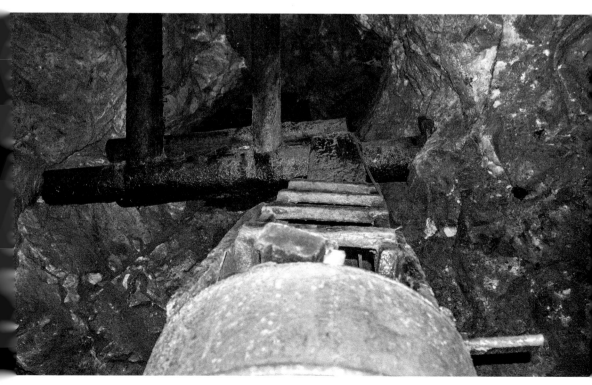

Keep looking up.

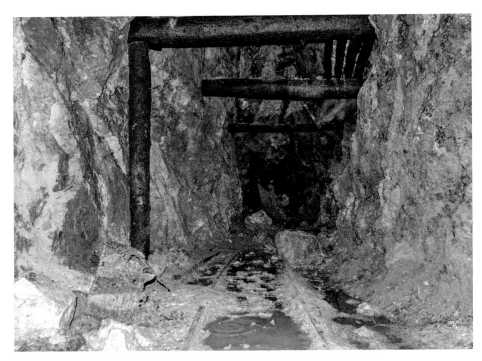

Water has slowly seeped into this mine, causing the weak layers of rock, clay, and mud to cave in.

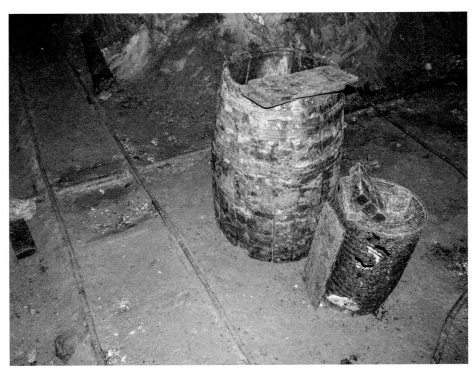

I'm not sure what this barrel or can used to contain, but I appreciate its own distinct beauty. Simple objects like these create beautiful examples of how powerful Mother Nature can be.

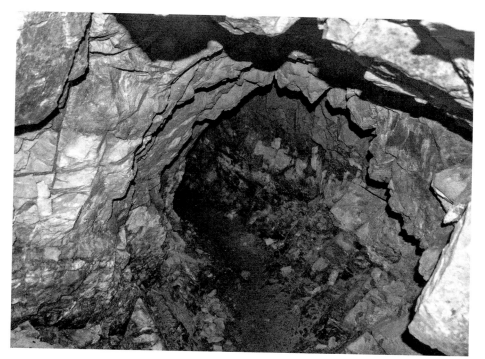

This tunnel looks like a head injury waiting to happen.

Fungi grows on the damp decaying wood, creating vein-like patterns. Underneath, a blasting wire remains exposed.

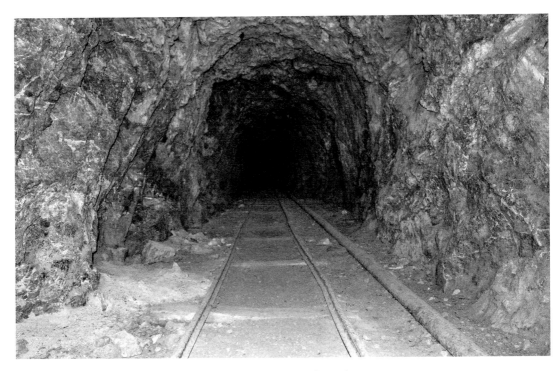

Dark tunnels beckon me to explore them, my curiosity driving me forward.

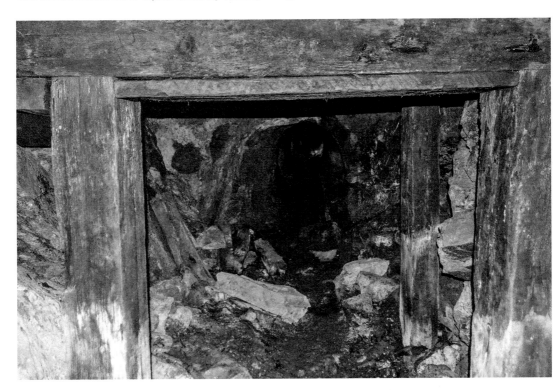

Crumbling walls put pressure on the remaining supports. One day, they too will collapse.

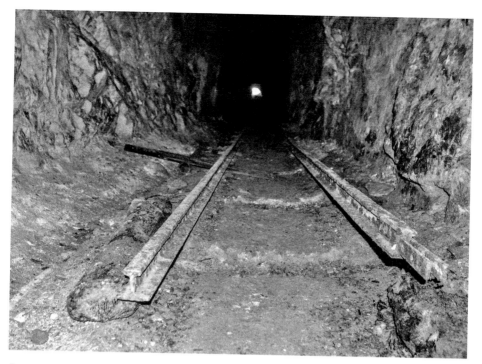

Go towards the light.

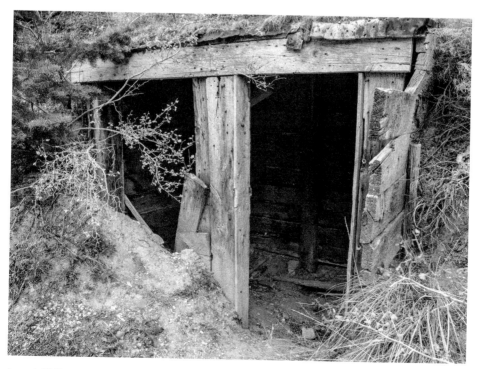

I was initially attracted to this spot, thinking it may be an entrance to a mine shaft. No such luck this time, for it appears to be a small storage space.

5

SILVER KING MINE

Next, I go over the mountains into the Park City area, where old mine life now intermingles with a new booming industry, the ski industry. The Silver King mine was a result of the consolidation of mining claims in the Treasure Hill area of current-day Park City, ultimately forming the Silver King Mining Company in 1892. As the years went on, further consolidation of claims around the area led to the development of the Silver King Coalition Mines Company in 1907. Three other mines combined to form the Park City Mining and Smelting Company, which was later joined with the Ontario and Park Utah mines, leading to the formation of the Utah Consolidated Mines Company.

Due to inadequate surveying equipment of the time, there was much feuding concerning whose mine claim was whose. By January of 1907, all parties involved had grown tired of the constant claim disputes leading to the consolidation of multiple mining claims. Here is an excerpt from the decision to consolidate:

In January last, in order to put an end to all pending litigation, the Silver King Mining Company arranged for the purchase of all holdings in the district of the plaintiffs in the cases filed against it. Through this transaction, the Silver King came into possession of a large area of additional territory, and this was followed a little later on by the formation of the Silver King Coalition Mines Company, which absorbed the property of the original Silver King company.
Engineering and Mining Journal, January 4, 1908, Volume 85, Number 1, page 46

The Silver King mine was located high within the mountainside. The road to get to the mine was steep and dangerous. Loaded ore cars struggled to make the trip safely and transportation of the ore by wagons was also hampered due to seasonal hazards, which included but were not limited to mud, snow, ice, and harsh temperatures. To combat these hazards, an aerial tramway was installed in the early 1900s. Over 7,000 feet in length, it took ore from the mine down into Park City where it could be processed and sorted. The tramway remained in service until the 1950s when the Silver King mining coalition merged yet again, forming the United Park City Mines

company. By 1953, most of the ore was transported underground when an old drain tunnel was expanded. The building where the tram was housed in park city remained for several decades after its last use and became a historical symbol of the Park City mine industry. This abruptly ended in 1981 when it burned to the ground.

With its history rich in mining fact and lore, I decided to journey up to Park City to see what's left of the Silver King Coalition mines. A friend of mine had explored the area before and advised me of a starting point just up the hill above main street Park City. The hike initially starts up a paved private road that is closed to vehicle traffic but open to hikers. Several trails branch off the road, making it easy to take a wrong turn. With my insider information, I was able to pick the correct trail right away, eventually leading me to the mine. The hike to the remaining mining structures is steep and rocky. The area now has been taken over by a ski resort, so the countryside is littered with snowcats, ski lifts, and other pieces of equipment required for the smooth operation of a ski resort. Luckily for me, the resort allows individuals to hike among the ski trails. I pass several other winded hikers who had stopped to catch their breath along the steep, unforgiving terrain. Another benefit of my constant exploration is physical fitness. These adventures not only quench my thirst for discovery but also keep me in shape.

After hiking a mile or two, I start to see mining structures peeking at me in the distance. Located near a modern ski lift house is the first building. This rusty old wreck of a structure appears to be safe and solid upon first viewing. As I get closer to it, however, I noticed it is no longer structurally sound. The roof has completely caved in, exposing the inner workings of the building to the elements (and my camera). Rather than venture into this structure like I normally would, I opt to take the safe route and photograph the external facade of the building. I venture behind the building where I am able to climb up the hillside directly behind it, granting me a view of the interior through the caved-in ceiling.

I see buildings scattered throughout the mountainside. An old power plant that once supplied the electricity needed to run the mine lies open and abandoned. Walking through it, I photograph the electrical equipment. Looking more like a prop in a horror film, it's hard to imagine that this used to be a bustling power plant. Trees grow through and break the old barbed wire fence that once kept people away from the high voltage equipment. Electricity no longer runs through these wires, allowing for safe exploration of the power plant. I exit the building and wander on down the trail unaware of the grand structure that awaits me.

Peering out of the trees like some sort of sleepy forgotten monster, a several-storied structure bears itself in front of me. At first, I only see part of the building, not knowing just how massive this place is. The contrasting yellow trees that surround

the brown structure make it stand out of the scenery. I snap a few photos and continue to a clearing offering me an even grander view of this massive place. The extent of the structure blows me away as I am finally able to see it in its entirety. I get carried away snapping photo after photo. Eager to explore the building, I backtrack down the trail and hike towards it. Before I can get to it, however, I am distracted by several other buildings that I had not initially noticed. While these buildings are not nearly as grand as the one I had just viewed, they are visually and historically interesting in their own right. So, I stop to explore them.

One structure bears a faded construction date marking when the building was initially completed. Inside of it, I find what appears to be an old workshop of sorts. The first room I enter looks to be a wide-open garage space allowing for plenty of room for vehicles and other equipment. Walking up the steps to the second floor, I find office-like rooms. Ceilings, walls, and even the floor have begun to cave in. Water damage and lack of upkeep are leading to this structure's inevitable demise. Going back down the stairs, I find a dark room hidden in the back. I point my camera into it and fire my flash. Upon looking at the image, I notice old ski lift chairs being stored in the back corner. These chairs have long since been forgotten and will most likely never again be used on the ski lift. I explore the last few rooms, snap a few more photos, and head on out of the building onto my main destination.

A short hike down the hill from the previous building takes me to the main mining structure. A place like this is what my dreams are made of—a massive playground for abandoned junkies like myself. I feel overwhelmed by its grandness and find myself with my jaw open, shocked by the beauty of it all. After admiring its vastness for a few minutes, I get to work exploring and photographing this wonderful structure. The lower room is more or less wide open. Windows line the entire front wall of the building, granting beautiful views of the surrounding forest. The ground floor is relatively open with pieces of machinery lining its back walls. The structure is built partially in the hillside, incorporating the earth into its foundation. This may have helped it survive for all these years due to the fact that the main wall has been supported by the mountainside. This also has its downfalls as well, for parts of the hill have begun to push into the building.

Many rooms in the building appear as if they are waiting to resume production. Tools lie on the tables and machines still appear oiled and ready to be used. Various shops and workstations can be found throughout the structure, each having its own specific importance to the entire mining operation. Boilers, water towers, conveyor belts, gears, furnaces, and a plethora of relics remain filling the structure with precious relics of the past. I continue to climb higher and higher up the structure, one sketchy ladder after another. As I get closer and closer to the top few floors,

more and more artwork begins to appear until I reach a wonderfully colorful room.

Paint cans lie all over the floor leftover from the urban artist's work. As impressive as the artwork is, I feel slightly disappointed that many of the artists have littered the area. I do my best to pick up what trash I can, but my camera bag is only so big. In one room, I find a spray-painted image of a man holding a suitcase. I have seen this image in many other locations and have recently found that one person, in particular, is responsible for this work. Almost like their signature, every abandoned place they explore is marked with this suitcase man. Maybe one day I will meet this artist, for I am sure that we would get along. To this day, I continue to find the suitcase man in almost every abandoned place I have been, including the aforementioned Bauer.

Moving on from this pleasing room, I explore the inner workings of the old machinery. I find a dark hallway with a track running down the center. Using my flashlight, I venture onward and discover that a mess of gears and belts surrounds me on either side. These particular pieces of machinery look as if they were designed for torture. Dark spots where oil remains on the gear appears as if they are covered in dark blood. I let my imagination run wild as I snap photo after photo, capturing what lies hidden in the darkness. After reaching the top floor, I backtrack through the building, exploring every nook and cranny I can before I leave. I don't know how long this location will remain, for progress and expansion of the surrounding ski resorts may one day be the demise of this spectacular location.

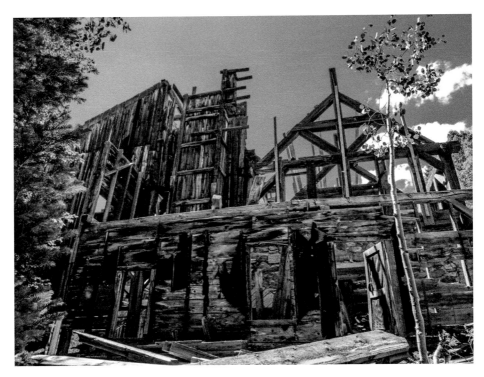

Blue skies and green trees stand as a direct contrast to the browns and grays of the rotting wood.

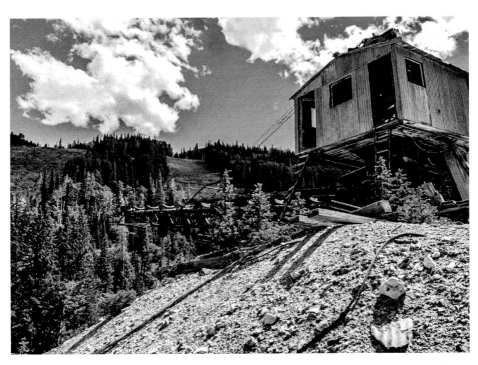

Ski resorts have grown around this old mining structure, incorporating the industry of the past with the thriving recreational economy of the present day.

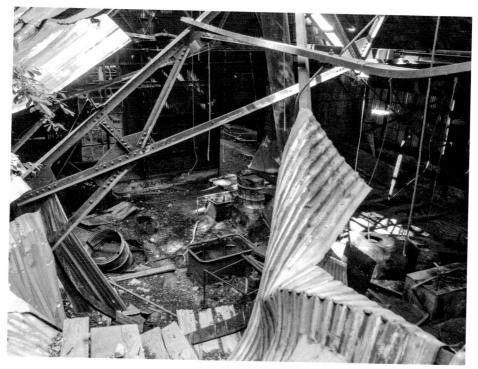

A gaping hole in the ceiling exposes the inner-workers of this building.

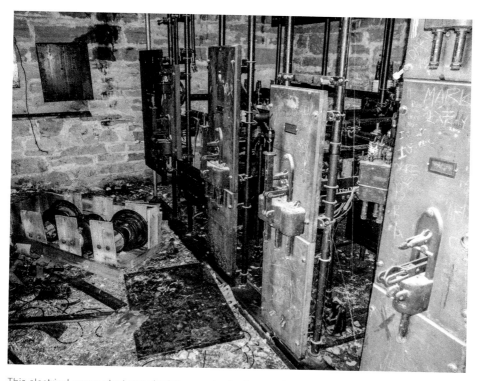

This electrical power plant once had thousands of volts coursing through its wires.

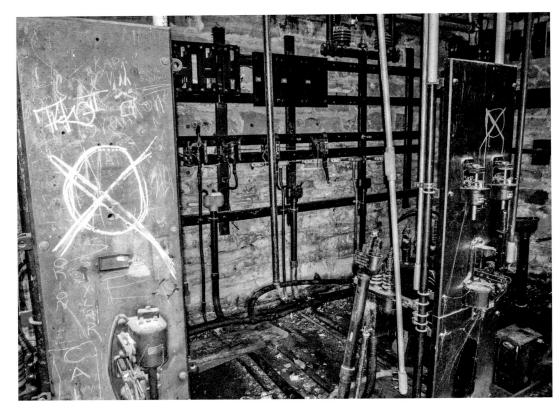

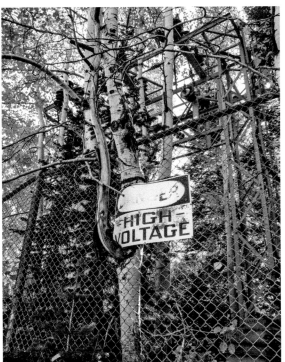

Above: X marks the spot.

Left: Danger High Voltage.

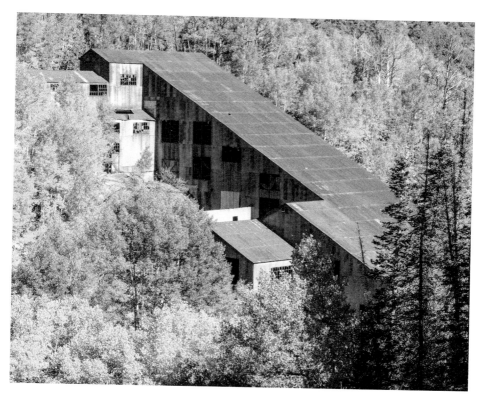

One of the grandest buildings I've ever explored, this structure stands tall and magnificent amongst the colorful autumn leaves.

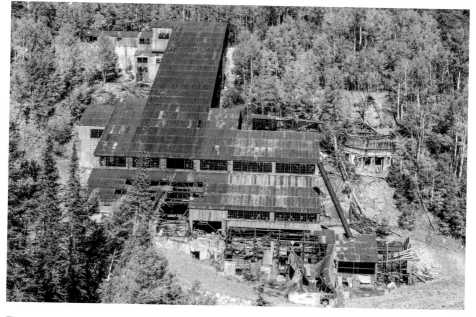

The pure scale of it can be appreciated from the opposing hillside. Broken windows litter the building as it clings to the mountainside.

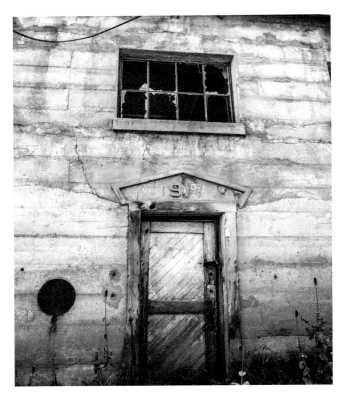

Left: Established 1917.

Below: Spiderwebs accent the doorways and stacked ski lifts can be seen being stored in the back.

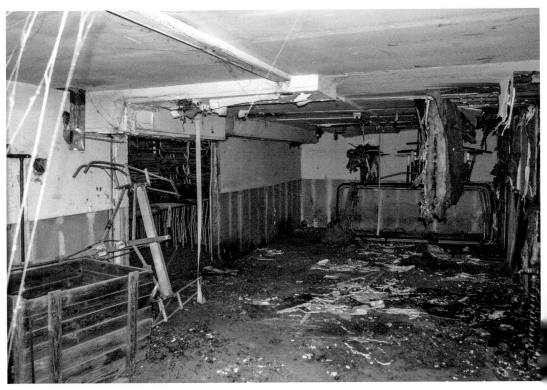

Bullet holes and shattered glass provide a murky view of the outside world.

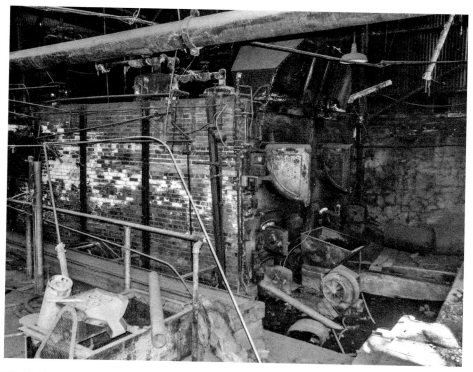

What looks to be a giant furnace now lies somnolent, never to be used again.

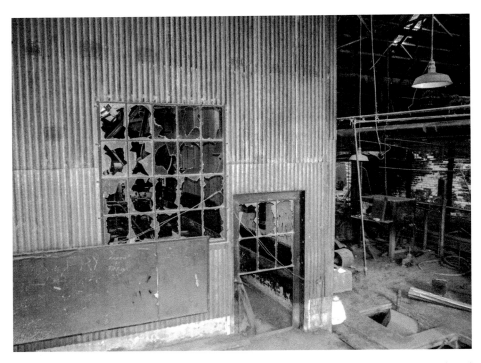

Chalkboards like these were used to keep track of tasks as well as help to calculate mining depth and tonnage of the ore.

Trees slowly grow into the building, their roots helping to slowly tear the structure apart.

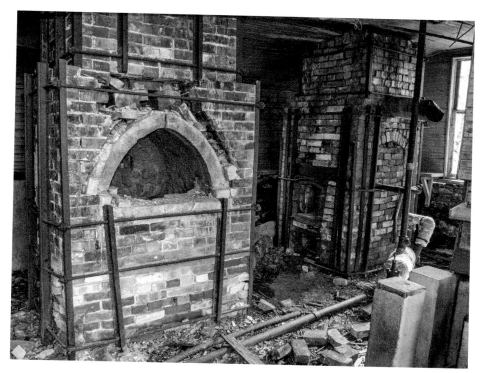

Inner workings still remain, although they are far from being in working order.

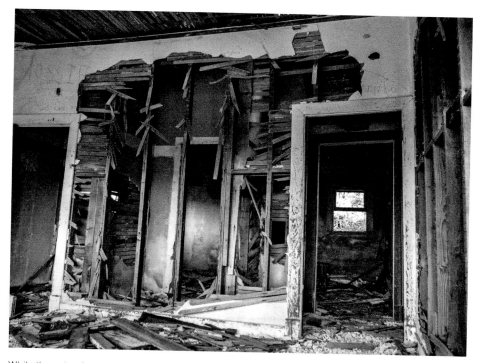

While the natural environment has a great effect on the conditions of neglected buildings, young adults do, too. Surely the decay of these walls was assisted by some youths.

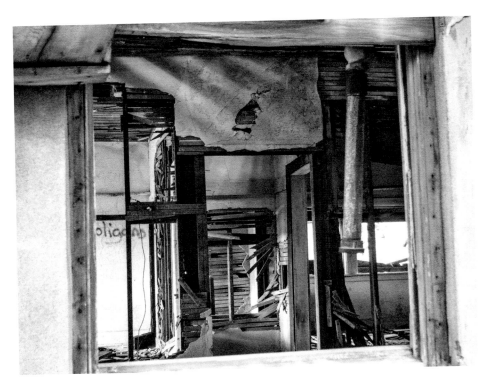

Hooligans.

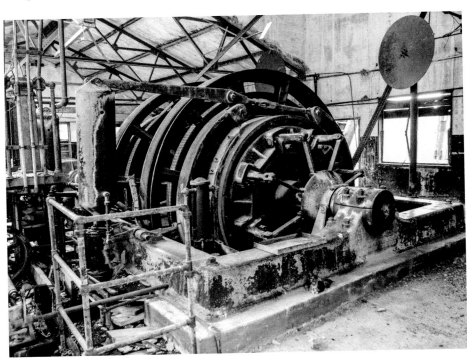

Imagine how dangerous it must have been for the machine workers. Safety wasn't nearly as important during the days of this mine's operation.

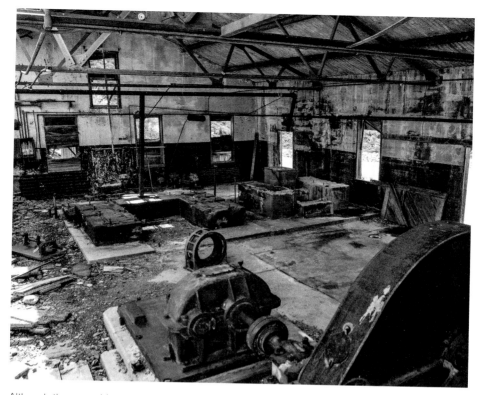

Although these machines may never be in working order again, one can't help but imagine how loud they must have sounded when they were in operation.

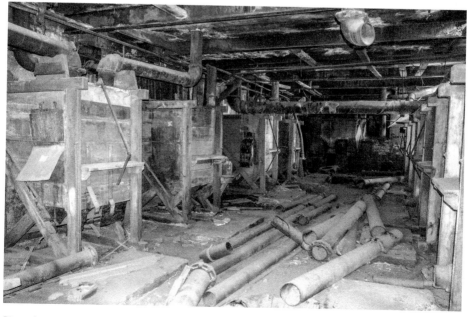

Pipes that were once connected to one another lie in a heap of metal on the floor. Big hoppers border the walls and hint of their past industrial purpose.

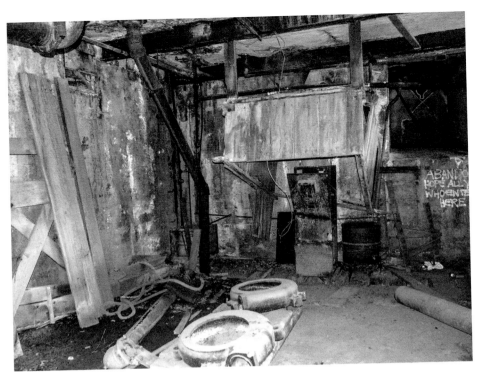

Abandoned hope all ye who enter here.

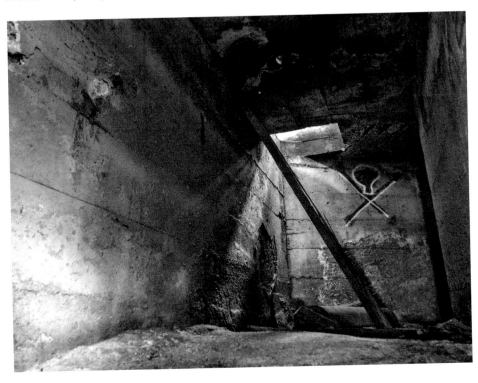

The Devil's Chute.

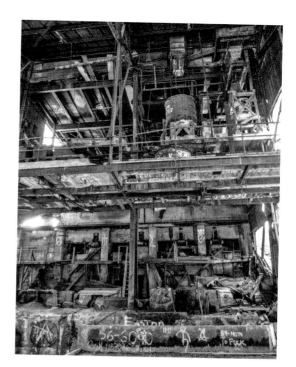

Right: Layers of decay present themselves as I climb higher and higher into the structure.

Below: Silver King Coalition Mine Co.

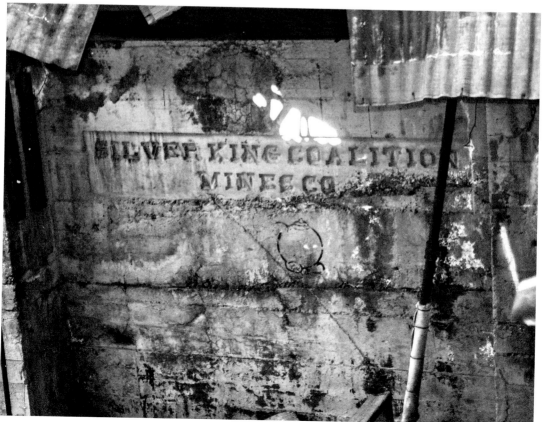

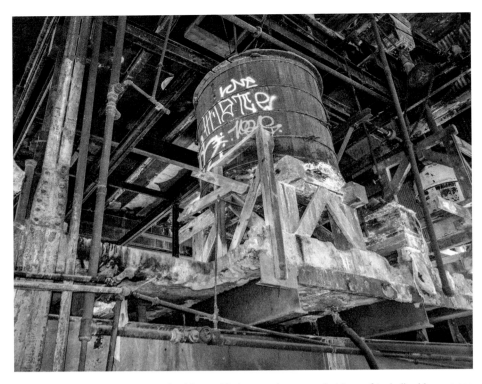

An eroded tower seeps corrosive liquid out of it. I can only guess what type of toxic liquid was once stored within it.

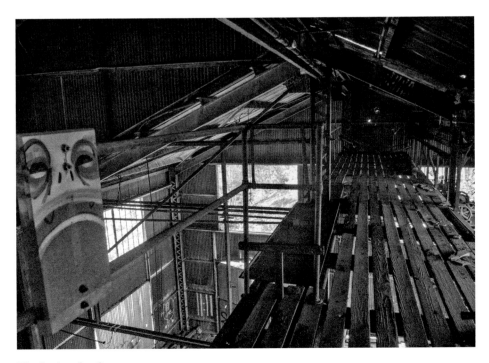

Why the long face?

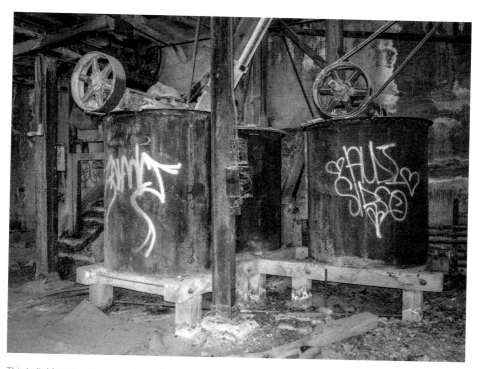

This belt driven machinery creates an industrial portrait of the inner workings of an early-1900s mining operation.

Framing history.

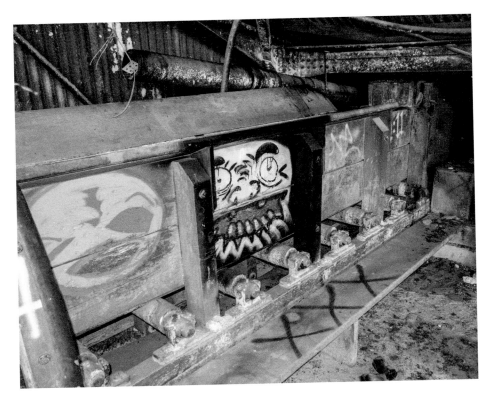

Here there be monsters.

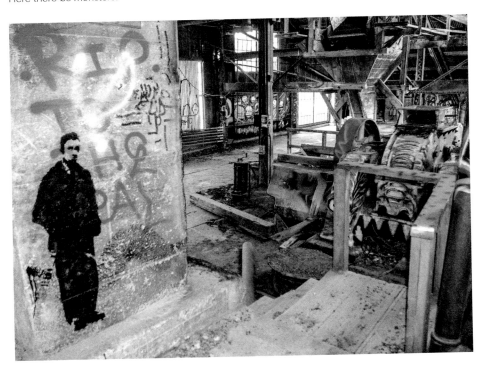

The mysterious dark man.

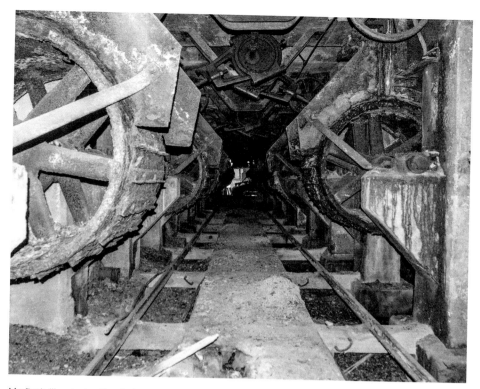

My flash illuminates the dark corners, revealing the intimating ghosts of industry.

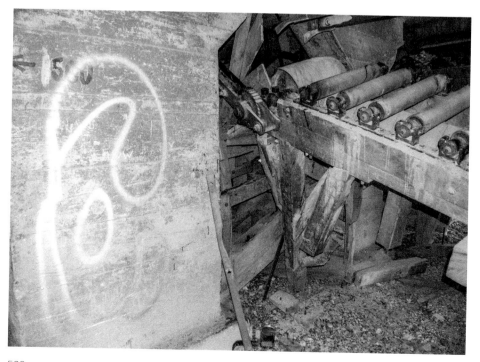

500.

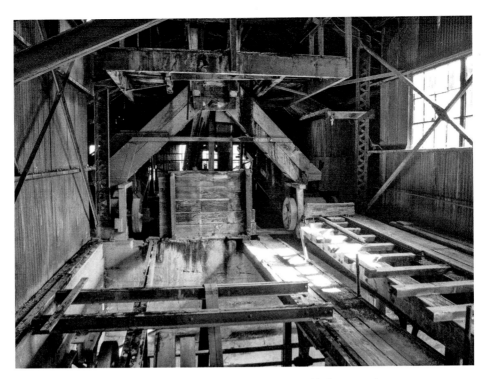

Light transudes through the windows, bathing the old rotting wood in its warm glow.

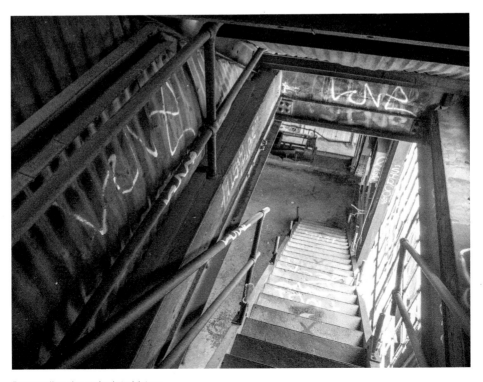

Descending the stairs into history.

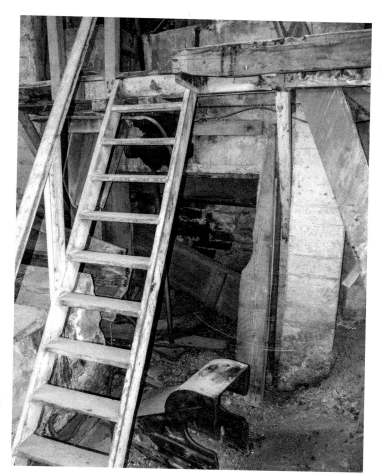

Workers once scurried up ladders like these busy about their day. Now these ladders support explorers like myself, still proving useful after all these years.

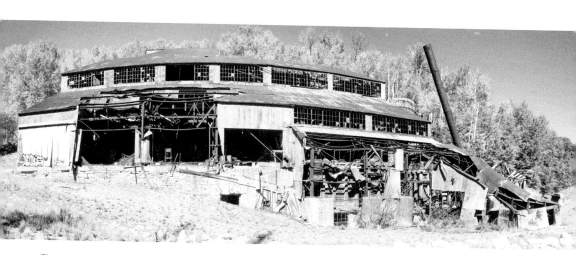

The exterior of this grand building. A panoramic shot stitched together in post processing.

6

URBAN ENVIRONMENTS

Now that we've spent some extensive time in and around the mountains, let's switch things up and head to an urban location. Every city has its crumbling areas and Salt Lake is no different. Places that once were filled with prospering businesses and warm cozy homes now remain crumbling and cold, forgotten by most. Just like the mine tunnels, urban locations have their own unique risk that one inherits when exploring them. I have heard horror stories of photographers and urban explorers getting attacked by squatters. While I have never been attacked before, one of my friends has. She was exploring an abandoned section of the subway in New York City when a homeless person ran at her with a knife. Luckily for her, she escaped unharmed.

Since drug addicts and squatters often make these places their home, I usually explore places like this with at least one other person. This reduces the risk of being robbed and/or harmed. Keep an eye out for dirty needles and other sharp objects left strewn about the floor, for inner-city locations almost always contain them. Now that we've accepted the possible risks, let's get back to exploring.

My good friend and fellow photographer, Jamie Thissen Betts, regularly uses abandoned urban locations for modeling purposes. While I prefer my models to be rusted and decayed, we both share a passion for exploration. We regularly share information about locations and often go on photo explorations together. Jamie suggested I use the following locations for this book and graciously gave me a tour.

An old open warehouse greets us. Chunks of the ceiling have been wiped away from years of being subjected to high winds and heavy snowfall. Graffiti covers almost every inch of the walls, varying in artistic quality. I find remains of a quarter pipe and a grind box supplying evidence of skaters. Trash is piled high in the corners, no doubt a result from years of squatters and skaters hanging around. It's a cold day and I feel even colder in this warehouse, open to the elements. I keep checking my camera battery knowing its life expectancy decreases in cold temperatures. We continue inside the main structure.

Picking our way through the rubble, we walk through the doorway and into another cold building. At least this building still has a portion of its roof intact. A central structure beckons me to move towards it. The light from the holes in the ceiling illuminates it as if it's some kind of holy structure. The charred walls around it bare the evidence of a fire. An old couch and a chair remain facing the crumbled structure, almost as if it is a stage. Colorful graffiti decorates the ruins, granting it a dark unique beauty. Our tour continues outside where an abandoned courtyard awaits our exploration.

Outside, wide-open grass is surrounded by destruction, creating an everlasting reminder that nothing is permanent and the earth will reclaim all. Just like other structures in the area, these walls are covered in art. Wonderfully bright colors seem to jump out at me capturing the attention of my camera. I meander through the open spaces exploring every inch, for I never know which photo will be my favorite. That's the exciting thing about photography. The first initial shot provides excitement and I get to experience new excitement later when I review the photos, noticing things that I hadn't noticed at first glance.

After thoroughly exploring things outside, I find another building that has a hole in its walls, allowing access to its basement. Before adventuring down the crumbling hole, I notice what appear to be boilers and a furnace of some kind. One of these objects has a spigot of sorts drawing me to the conclusion that it once held liquid, possibly as a water heater. The boiler still has ornate details decorating its exterior and bears the name of the location where it was produced, the Erie Iron Works in Erie, Pennsylvania—a long way from its final resting point here in Utah. These objects were no doubt once housed under the safety of a roof and now lie exposed to the weather. Trees, vines, and roots have begun to entangle the objects, appearing as if Mother Earth is slowly pulling them back into the ground.

Adventuring on into the dark and dreary basement, I find a vast open space with little to no remnants of its past tenants. Support beams continue to hold the structure above creating an eerie crypt-like appearance. I hadn't anticipated exploring a dark mine-like basement on this particular photography adventure, so I rely heavily on the flash from my camera to illuminate the space. My autofocus struggles to find points to reference, so I manually lock the focus ring on my lens and fire aimlessly into the darkness, eager to view what my flash reveals. I find graffiti left behind by a fellow explorer stating the eerily accurate words: "History dies … Condos Arise …" This is an unfortunate truth of progress. In many instances to advance as a society relics of the past are destroyed making way for new business and housing developments. Progress is a double-edged sword. Advancements are often necessary to improve our quality of life and advance our knowledge, but that often comes

with a heavy price. They say that history repeats itself. If we destroy the remnants of our past, we are doomed to repeat the same mistakes made then in the future. I believe this grants even more importance to the type of photography I participate in. Many of the locations I photograph will soon be gone forever, leaving us with nothing but photos to remember them by.

I find an old freight elevator sitting eerily quiet in the center of the structure. I wonder how many heavy objects and supplies were loaded here and brought up to the main floor. I stand in the center of it wondering if it could still hold my weight. The curious part of my mind reaches for the controls, hoping it still works. Unfortunately, nothing happens. The electricity used to power the building has long since been shut off. Can't blame me for trying though!

I take one last photo before exiting the gloomy basement. An old access window appears to have been broken for quite some time, undoubtedly from the pressure of the earth pressing upon it. Rubble from the collapsed outdoor walls has slowly begun to fall into the basement. Leaves and other biological debris have followed suit as well. Without any upkeep or cleaning, I am almost positive that one day this basement will be filled in completely with both natural and man-made rubble. The upstairs portion of this structure is no longer accessible to exploration, leaving only the basement left to explore and photograph. While disappointed by this fact, I am still very grateful to have been able to explore what is left of this decaying urban structure. For every new location excites me and feeds into my passion for exploring the dark and forgotten places of Utah.

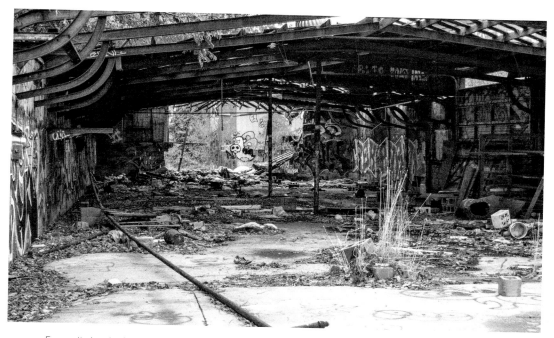

Every city has its fair share of abandoned buildings and Salt Lake is no exception. Squatters and artist frequent these places, turning them into their own safe haven.

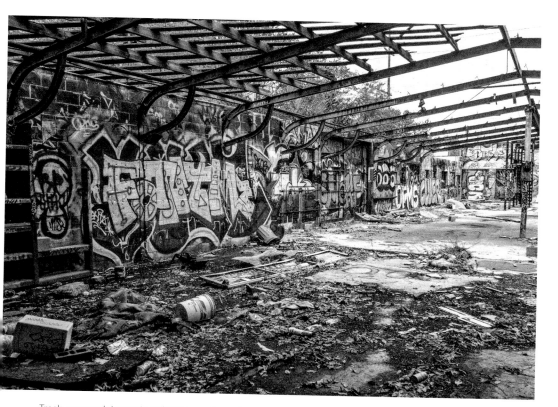

Trash accumulates as transients pass through.

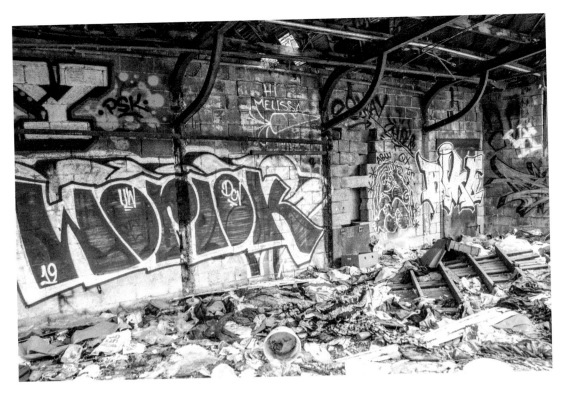

Hi, Melissa.

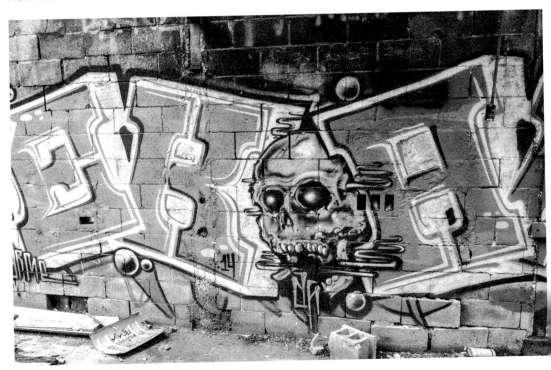

The stunning artwork makes braving the sea of trash worth it, just watch out for dirty needles.

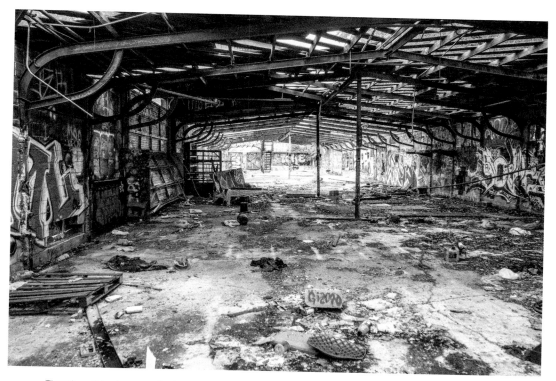

There's nothing to cover the interior of this structure, allowing for its erosion and decay to accelerate.

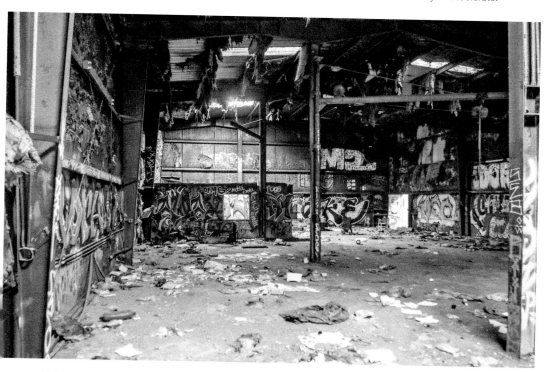

Welcome to M2, the nightmare factory.

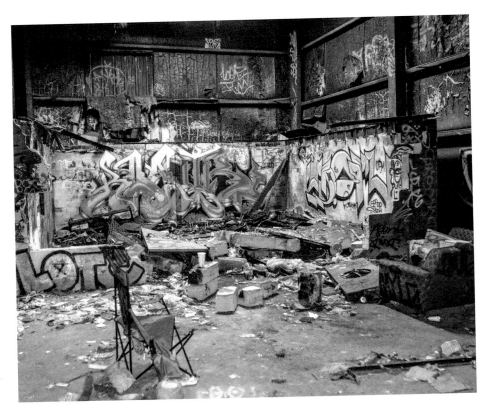

Best seat in the house.

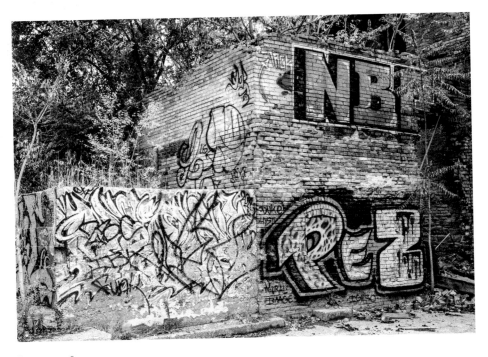

Pez anyone?

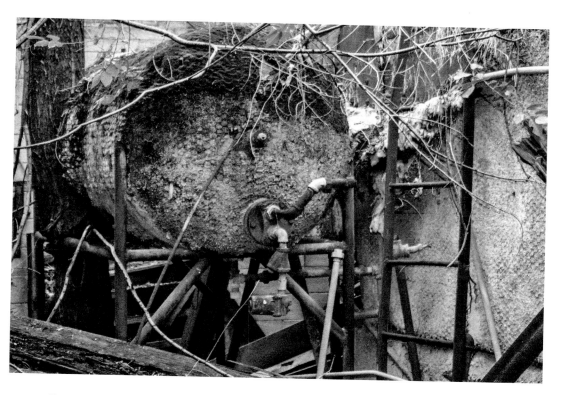

Above: Parts of this building are completely gone, exposing what looks to be some sort of water tank.

Right: Erie City Ironworks. Erie, Penna.

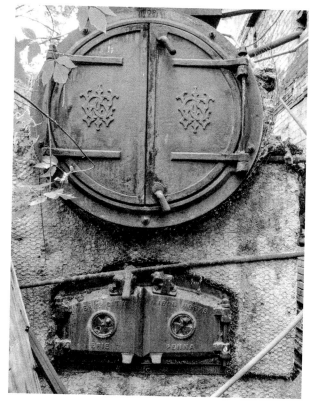

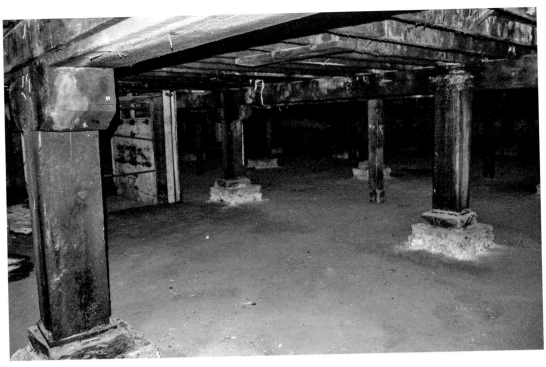

Not much to see down here. Just a dark and dreary basement.

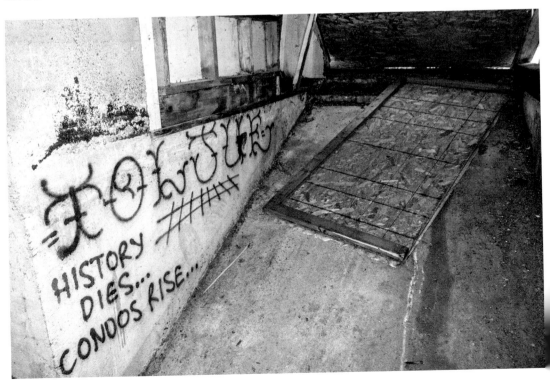

HISTORY DIES...
CONDOS RISE...

Not truer words have ever been graffitied.

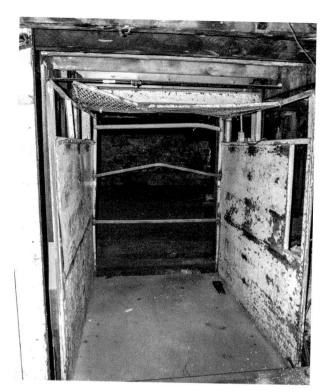

Right: I think I'll take the stairs.

Below: Breaking and entering, environmental style.

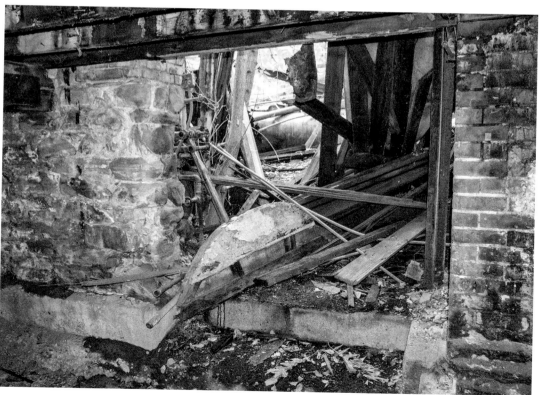

7

COTTONWOOD PAPER MILL

L eaving the downtown area, I head east towards the base of the mountains only a mile or two from the mouth of Big Cottonwood Canyon. In the late 1800s, this area was settled by those who did not what to live in the developing metropolitan area of Salt Lake City. What is now a bustling suburban expanse at the gateway to the heart of ski country was once considered to be frontier land. It was the last stopping point before venturing up into the mountains. Miners and loggers frequented the stores, saloons, and hotels that were once operating here. While few artifacts remain from those early years of settlement, one structure has barely survived the ravages of time.

The Cottonwood Paper Mill was erected in 1883. Becoming too reliant on eastern paper companies, the Deseret News Corporation decided to produce its own paper. The location was picked due to its proximity to multiple logging camps. Pulp from aspen trees was added to the rag mixture that was used to create paper at the time. Prior to the construction of the mill, representatives of the Mormon church were sent from house to house collecting rags to be used for paper production. With this new mill, fewer rags would be used and paper production levels would increase. Cotton, hemp, wallpaper, and linen were all added to the pulp mixture. This mixture was then poured into a mold and dried, resulting in paper. When the mill was in full operation, it produced roughly 5 tons of paper per day.

In 1892, the mill was sold and renamed to the Granite Paper Mill. The Granite Paper Mill did not last long, however. On the first of April 1893, a fire broke out, causing extensive damage to the structure. The muddy spring conditions of the area had hampered paper deliveries, leading to a buildup of paper and paper making supplies. The initial fire alarm was ignored at first, for the first of April is known as April Fool's Day causing many residents to believe it to be a joke. By the time the community responded to the fire, it was too late. All that remained of the mill was a skeletal structure. In 1927, the mill was re-opened as an open-air dance hall called the Old Mill Club. The club operated until the 1940s. Since then, the structure

has been used as a haunted house attraction and an open-air craft market. It was designated as a historical site in 1966, providing it some sort of protection. By 2005, the mill was officially condemned by the city of Cottonwood Heights.

The future of the structure remains unknown, as it now sits abandoned. The mill is covered in no trespassing signs, leaving me to explore it from the streets. As frustrating as this is, I feel it is important to abide by the rules. Being respectful of closed off and private property leaves for less harassment and possible legal prosecution. With that being said, the mill still presents itself as a stunning structure. Many of its remaining exterior features look castle-like.

The walls surrounded the great open courtyard appear to me as if they could be a defensive structure. As usual, I let my imagination run wild as I snap photo after photo. The cold, crisp day I chose to photograph this mill adds to its beauty. Mountains behind it encase the structure in wonder, granting it an impressive emotional presence. The majority of the remaining windows have been either broken or boarded up. The remaining enclosed space has been permanently sealed to prevent squatters and drug addicts from taking up residence. Barbed wire surrounds the structure, giving it a cold and foreboding presence. Even though it has been registered as a national historic site, the fate of the Cottonwood Paper Mill remains uncertain. For now, the mill stands as a silent reminder of past industrial history, quietly awaiting its unknown fate.

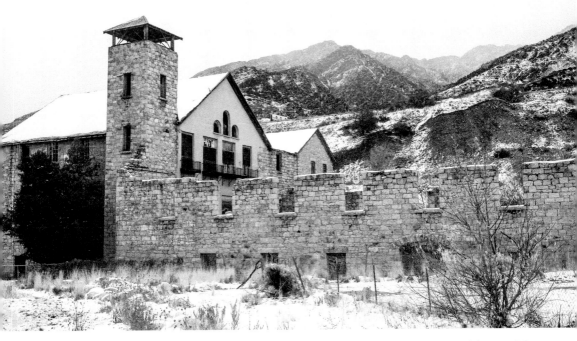

Above: Some locations I just can't get into. A street view of this mill will have to do. The coldness of the mountains gives this location a very chilly feel indeed.

Below left: Boarded windows hide the emptiness held inside. A grand effort has been made to keep squatters away.

Below right: The barbed wire that surrounds the perimeter of the mill makes it feel more like a prison. The looming tower reminds me of a guard tower.

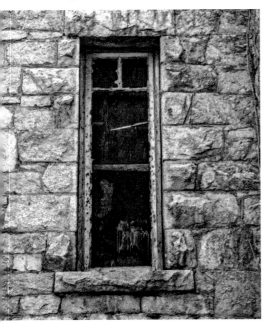

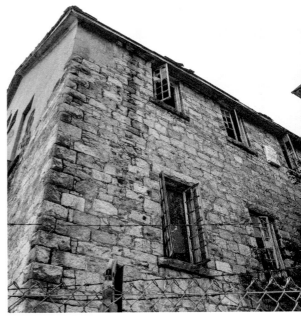

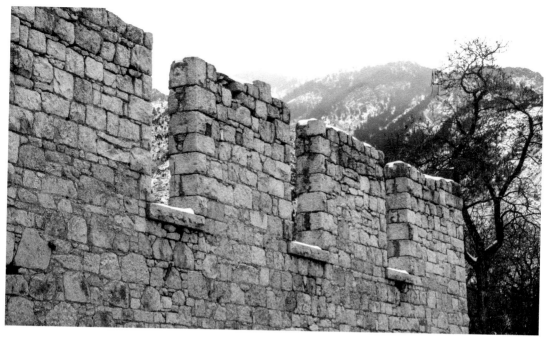

Cold castle walls.

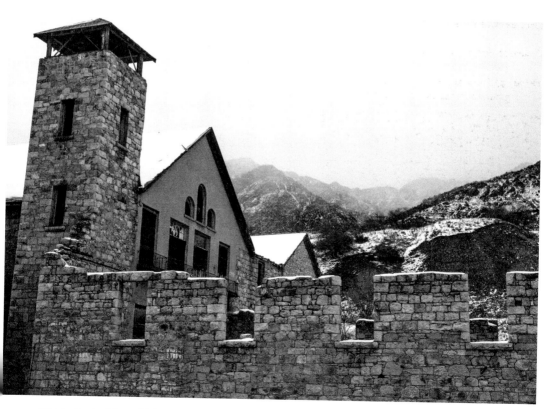

One last look at the cold, icy structure.

8

MARYSVALLE

Marysvalle, Utah, is a semi-isolated town located near the southern portion of the state in the Tushar Mountains. Once a thriving mining district, it has now become a paradise for those looking for off-road adventures, beautiful hikes, rafting excursions, and mining history. The famous outlaw, Butch Cassidy, once called this area home, and a short 20-mile drive south of Marysvalle will take you to a well-restored house where Butch once lived. Bullion canyon is but one of the old mining encampments full of old remains from the mining years, including a well-presented miners park. Here, recovered artifacts that were found scattered in the mountains have been put in an open-air museum of sorts. Tools, mine shafts, and even an old mining cabin are presented in a historical and informative manner. Believed to be mined first by the Spanish some 300+ years ago, it wasn't until the early 1860s when more modern miners became interested in the area. Gold, silver, and many other precious metals were found and can still be found within the surrounding Tushar Mountains.

I have always been interested in mining history and the mining operations themselves; therefore, I was naturally drawn to the Marysvalle area. The road into Bullion Canyon just outside of Marysvalle can be rough depending on the time of year, so a high clearance vehicle, although not required, may be a good investment if you wish to explore the area. Hidden among the trees lies remnants of mining structures as well as many collapsed and partially collapsing mining houses. One house, in particular, was built onto a slowly eroding hillside so the remaining walls of the house seem to lean into the hill, creating a funhouse feel. When visiting the miner's park, be careful to take note of and obey the private property signs. Although a lot of bullion is on national forest land, many of the mine structures lay on private property. I am always very tempted to break these rules to capture the remnants of these mining structures, but the risk of being caught and possibly prosecuted outweighs the desire to get the shot. Luckily for me, there are plenty of accessible structures and artifacts to photograph.

The town of Marysvalle itself is strewn with abandoned and forgotten structures. A local guidebook can be obtained from many of the small businesses with corresponding numbers for each historical site. Rumored to be haunted, Moore's Old Pine Inn is a magnificent period building that is still in operation today. Built-in 1892, the inn is rumored to have housed such historically significant guests as Butch Cassidy and the author Zane Grey (who wrote Riders of the Purple Sage while staying at the inn). The Denver and Rio Grande railroad once passed through Marysvalle allowing the miners in the area to have access to the outside world. A paved bike path now follows the old railbed and just a few miles away from the town center an old railroad tunnel still exists. This tunnel is about 200 feet in length with vaulted ceilings measuring at least 20 feet in height. The charred ceiling remains as a reminder of the once-grand locomotives that used to travel through the area. The tunnel is in relatively good shape, but several spots have begun to crumble as time and gravity slowly wear away at its walls. I was able to go inside the tunnel and shoot several photographs as well as fly my drone through the center of it.

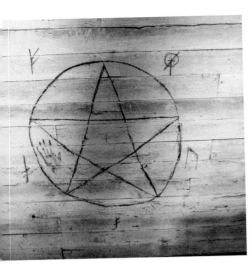

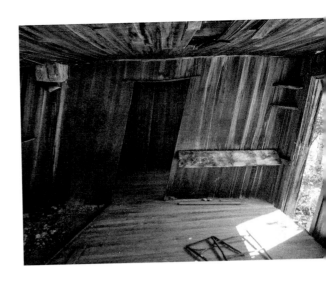

Above left: Satan.

Above right: While this may seem like an optical illusion, this diagonal house is being pushed over by the mountainside, giving it a crooked look.

Below: Tumbleweeds have collected inside this roadside find. One of the walls has completely collapsed allowing extensive exposure to the elements.

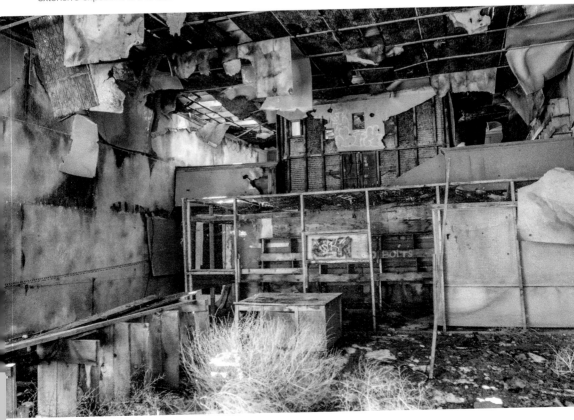

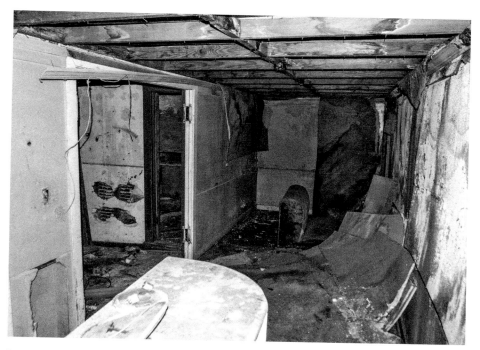

Dark and dusty, the interior has seen better days. Good choice in wallpaper color, though.

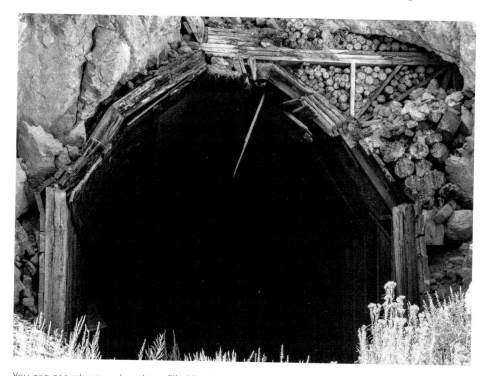

You can see where workers have filled in the gaps between the top corners of this abandoned train tunnel with lumber. While this may have seemed like a good idea at the time, it didn't age well. The tunnel has begun to collapse and may not be with us for much longer.

9

SOUTHERN UTAH

I spend a lot of time camping in the southern portion of Utah, mainly staying around the Capitol Reef and Escalante area. BLM land can be found scattered around the parks providing free-dispersed camping, or you can camp at one of the established campgrounds scattered throughout the parks. While most of these trips are mainly for hanging with friends, I always have my camera ready just in case. Going slightly off the beaten path can grant you isolation here. Stunning red rock cliffs decorate the countryside, making for spectacular images.

While out for a drive on one of the rougher four-wheel-drive roads in the area, my girlfriend and I found several old ranch structures. From years of being pelted by red sand, the dry rotted wood has become the same color as the surrounding landscape. While cattle are no longer corralled and branded here, the area still has multiple operating ranches. Some things never change. Driving along the Cathedral Valley Loop, great vistas and stunning rock formations await. Be careful though, this can be a rough and rocky drive not recommended for low clearance vehicles. But if you enjoy great views and adventure, this is the road for you. Keep an eye out, for a rusted treasure awaits you a few miles down the road.

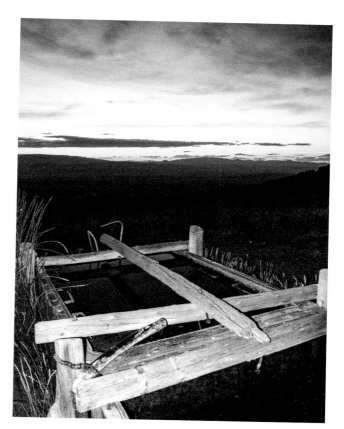

Right: While the sun sets on this old trough, its use still continues today by supplying water to open-range cattle.

Below: History frames the cliffs.

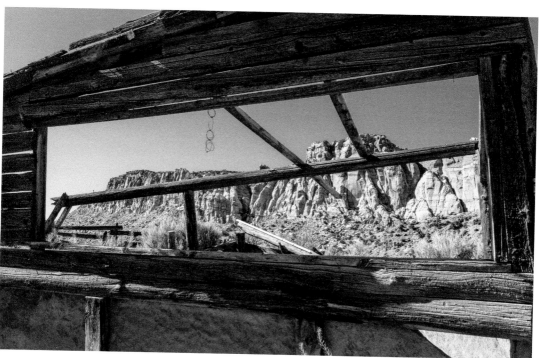

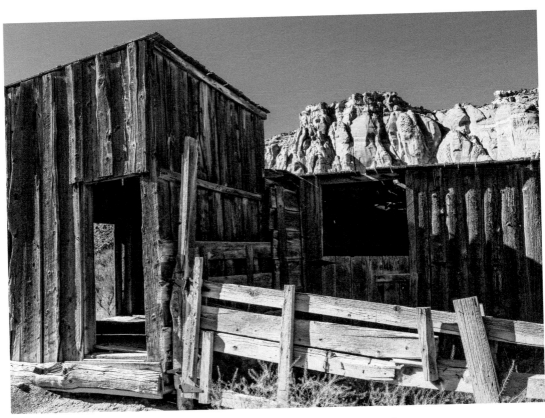

Structures slowly melt into the landscape, matching the colors of the surrounding cliffs.

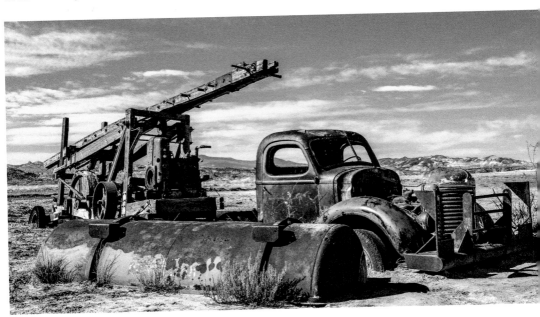

A rusted wreck of ingenuity lies within the southern desert of Utah. What looks like an ordinary broken down truck is, in actuality, a pump. It was used to keep livestock hydrated during the long dry summer months.

10

THISTLE

In 1983, tragedy struck the railroad town of Thistle. A landslide would eventually block the nearby Spanish Fork River, creating a dam. The rail lines connecting Salt Lake City to Denver were ultimately severed, costing millions in damages. A harsh winter followed by a wet and soggy spring had created perfect conditions for this landslide to occur.

In April of 1983, workers from the Denver and Rio Grande Western railroad had noticed that train tracks in the area had slowly begun to shift. Keeping a close eye on them for the next few days, workers continued to note that the tracks were shifting at an alarming rate. The nearby highway had begun to show signs of stress as well, buckling while the earth moved beneath it. By the end of the week, state officials decided to close the highway, deeming it too hazardous to drive on. Airing on the side of caution, railroad officials had decided to reroute trains going through the area. Crews worked around the clock, doing their best to keep the river from damming up and completely flooding the town. Their efforts were in vain, however, and the fate of Thistle was sealed.

The slide was moving way too quickly for workers to keep up, so the effort to keep the river open was abandoned. All residents were evacuated and within a few days, the slide had blocked off the river, causing water to drown the town. After some time, the railroad and highway were re-built, avoiding the area of Thistle. Considered to be one of the worst natural disasters in Utah history, the Thistle disaster wound up costing nearly $200 million in damages. While there's not much left of Thistle to explore, it is still worth a visit. The destructive power of Mother Nature never ceases to amaze me.

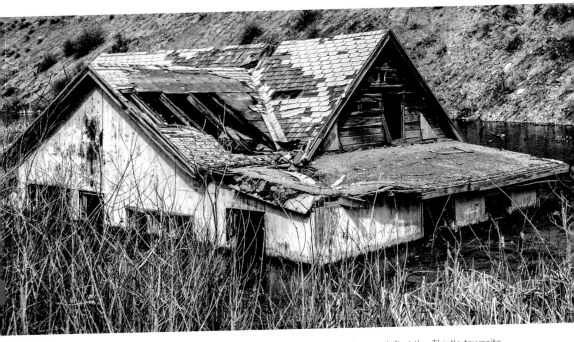

Partially sunken into the grey waters, this is one of the few remaining houses left at the Thistle townsite.

11

SWETT RANCH

Located in the Ashley National Forest, near the Flaming Gorge National Recreation Area, lies the well-preserved remnants of the Swett Ranch. In 1909, Oscar Swett began homesteading on his small land claim. Along with his wife, Emma, they raised nine children here. Surrounded by only a few neighbors, they had to rely on the natural resources of the area for survival. Believing in hard work and manpower, Oscar relied on his horses well after advancements in machinery had been made available to him. He believed that horses were more reliable than machines, because "horses don't break down."

Today, the ranch is operated and maintained by the United States Department of Agriculture's Forest Service. Tours are given during the ranch's normal operating season and if you get there early enough you may even get a private tour. This is what happened when I decided to drop by on an early summer morning. The ranger had just opened for the day and graciously showed me around. I was given access to closed-off areas and wound up spending nearly three hours exploring the ranch. I highly recommend making a trip up to the area. The well-preserved buildings and the knowledgeable tour guides will leave you wishing you were a rancher here in the early 1900s.

Above left: A tree grows through this rusted wreck, a testament to the decades since it was last parked here.

Above right: This shed was once used for storage. Now it rests silently greeting visitors at the ranch.

Below: Look into the reflection in this pane of glass and you will see other ranch structures that were built by Oscar Swett.

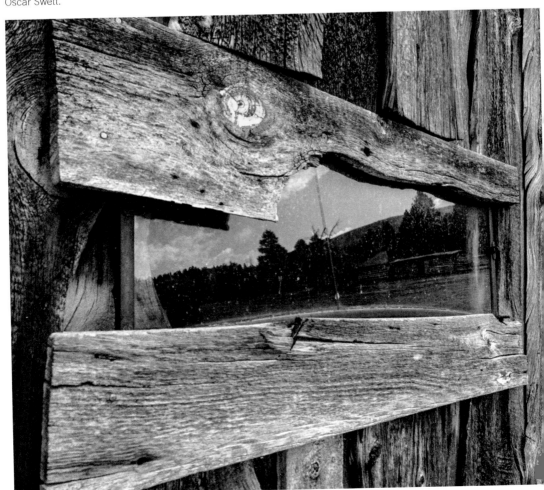

12

OPHIR

The Ophir area is a sleepy old mine town now home to just a few residents. Silver deposits were initially discovered here in the early 1860s by soldiers who were stationed nearby. The first few mining efforts yielded little success and the Civil War caused the original claim owners to leave the area to go and fight. As the war finally drew to a close, those who survived the carnage returned to their original claims and resumed mining operations. More lead and silver deposits were discovered, leading to a mining boom by the early 1870s. The small mining success of the area wouldn't take hold until the beginning of the 1900s. By 1911, zinc was discovered here as well causing an even further increase in production.

At its peak in the 1920s, Ophir had a population of roughly 500 people. This was a relatively small population when compared to the other booming mining towns of the time. Mining operations continued until the late 1950s when all large operations stopped due to decreased production. Today, a few small mining operations exist in the area, but the town's population has dwindled to just above twenty permanent residents.

I frequently visit the Ophir area, mainly to enjoy its peace and its stunning beauty. The center of town has several historic markers as well as a small miner's park where recovered mining equipment can be viewed. The surrounding hills contain a treasure trove of mining artifacts, including some very interesting ore cars. While not much remains of the original town, Ophir is well worth the visit for fans of mining history.

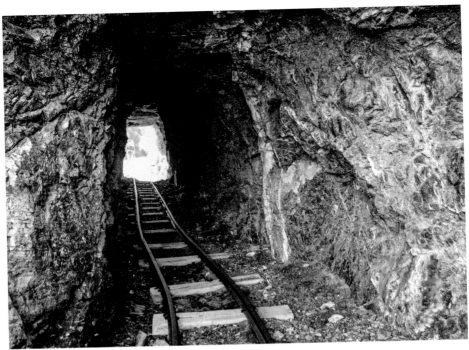

The hillsides of Utah are dotted with blemishes from mining operations. This tunnel was carved out of the mountains and was most likely used to move ore and precious metals to their final destination.

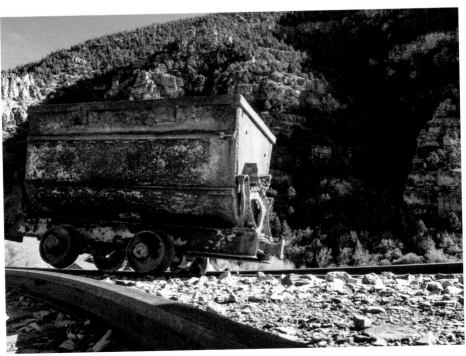

An ore cart struggles to hang onto the remaining rail. As time warps the tracks, it now seems to be stuck in a perpetual balancing act.

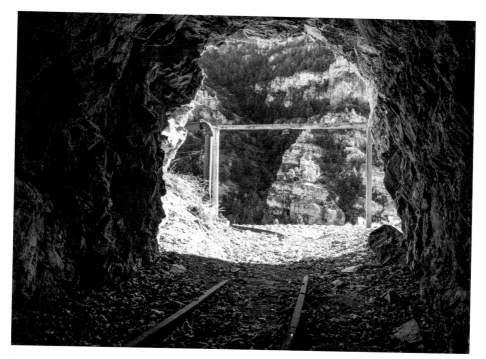

Many miners must have rejoiced when seeing this exact view, happy to have made it to the end of another hard workday deep within the mountainside.

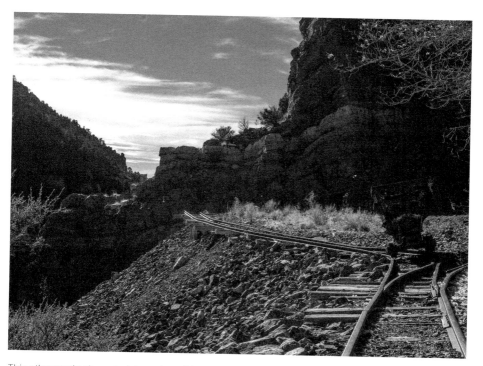

This other angle shows just how close this ore cart is to the edge. One day it will give way and tumble down the cliffside onto the road below.

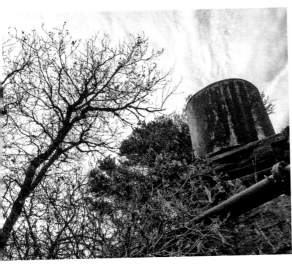

Above left: Even miners need water breaks! In reality though, this small water tower was used to help run and cool mining machines and drills.

Above right: Rocks outline a long forgotten grave. Its resident's identity has been lost to history

Below: Vines slowly engulf this abandoned home. They seem to squeeze whatever life is left out of the structure, contributing to its inevitable demise.

13

UNINTENTIONAL DISCOVERIES

The journey of the adventure is all a part of the process. Often while on the road heading to a specific location, I discover things that distract me from my original destination altogether. These secret gems of grime have caused me to constantly keep my eyes wide open, endlessly scanning the countryside for unknown buildings and middle-of-nowhere locations. I have unintentionally found abandoned places such as gas stations, houses, storefronts, ghost towns, buses, mills, and even mine shafts. Every turn around an unknown road becomes exciting and I slowly learn more about the abandoned history of Utah.

Not every photo adventure of mine is a grand success either. Many locations have been long gone, not leaving much to be imaged. But that doesn't make much difference to me. Every mile grants the exciting opportunity for a new experience. Every small town provides a wealth of historical information and expands my knowledge of this great state. The following photos are a collection of random areas that don't fit any specific section of this book. Each area is alluring in its own exclusive way and deserves to be photographically preserved.

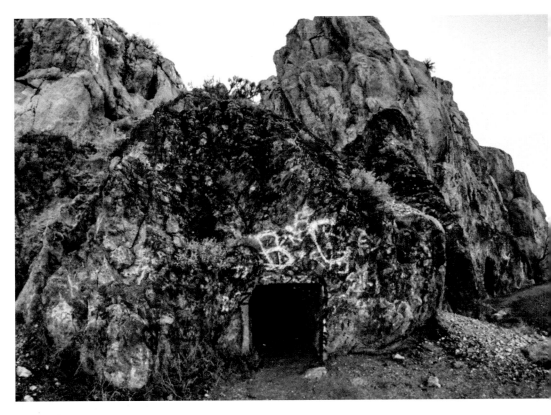

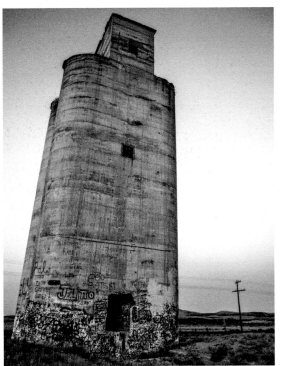

Above: It appears that someone carved a home right out of this rock. In all actuality, it was most likely used as a space to store goods and equipment.

Left: I found this towering structure nestled alongside some railroad tracks, possibly used to store ore until it could be loaded onto outbound trains.

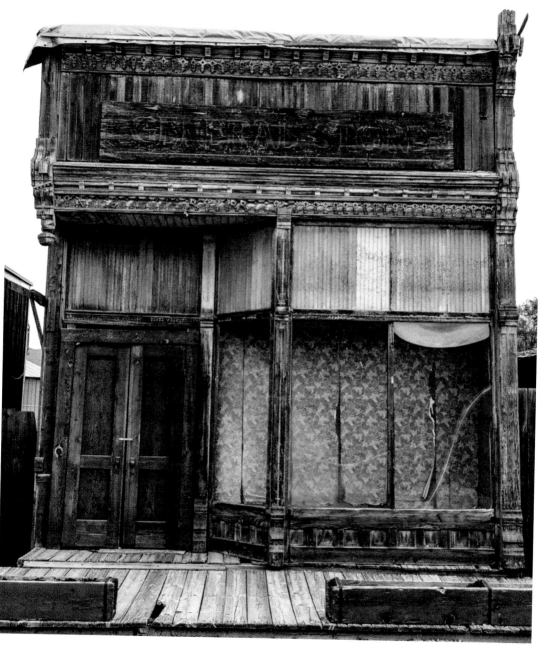

This general store has been relocated in an attempt to save it from its inevitable decay.

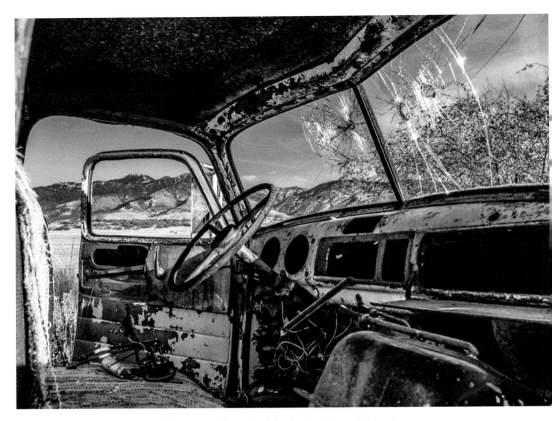

Bullet holes distorted the view of the surrounding mountains inside this roached-out car.

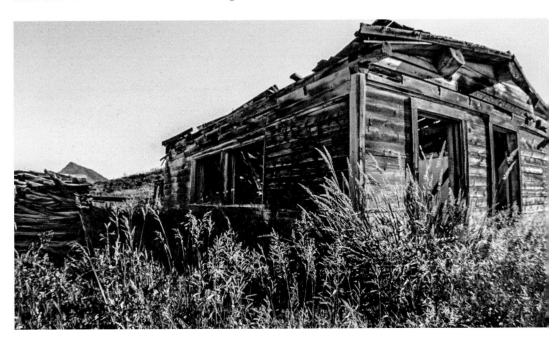

Collapsing ranch buildings like these litter the countryside of Utah.

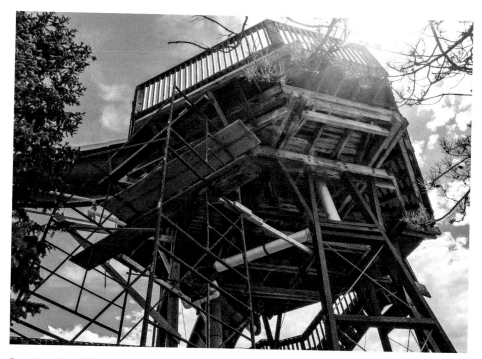

Towering above the remnants of a once-vibrant water park, this structure reminds me that even the most joyful locations will one day fall silent.

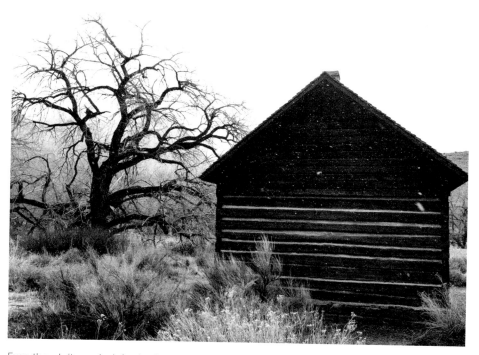

Even though it may look foreboding in the cold winter snow, restored buildings like this schoolhouse help link us to the past.

14

WENDOVER AIR FORCE BASE

In 1939, political turmoil had begun to wreak havoc across the globe. In an effort to prepare for an inevitable global conflict, the Army Air Corps had begun expanding their operations. The Air Corps needed new bombing and gunnery facilities to adequately train their troops. Nearly a year later, their search ended and they decided upon Wendover. At first, the Air Corp had asked for nearly three million acres to be set aside for their bombing range. Grazing commitments to local ranchers and farmers meant that only half a million acres would be set aside for use with the Air Corps. Despite this, the base was built and trainees began to arrive.

The desolate uninhabited terrain was perfect for bombing practice. Crews dropped both live and dummy rounds as they prepared for combat. By the time the war was over, twenty-one heavy bomb groups had been trained at Wendover. Many of these units went on to be highly successful throughout World War II. One of the most famous bombing units that were trained here was the crew of the Enola Gay. Here, they prepared for nuclear combat. Whether for better or for worse, the Enola Gay would go on to drop the first nuclear bomb ever used in combat on Hiroshima, Japan.

As World War II slowly neared its end, Wendover began testing guided missiles. Its missile program progressed, and the research continued into the 1950s when the first unmanned aircraft to break the sound barrier was tested over the airfield. An American version of a German V-1 rocket, the JB-2, was also tested here. Ultimately, Wendover had been rendered obsolete by the 1960s, leading to its closure by the United States Air Force in 1963.

Today, Wendover is still an active airfield, although it is far from what it once was. Hangars, barracks, a pool, and several other structures from the World War II-era still remain. Most of these structures are in rough shape. Luckily, there is hope for the future of the old base. Restoration projects have begun and the service club has been fully restored. You can take a tour through the club during the museum's normal operating hours. Work has begun on the hangar that once housed the Enola Gay as well. With support from the community, it is possible that someday this base will be restored to its former glory.

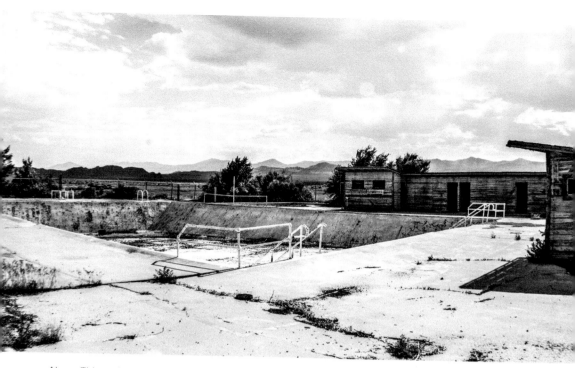

Above: This pool once provided soldiers sweet cool relief from the hot desert sun. It now lies empty, slowly filling with dirty rainwater and dust.

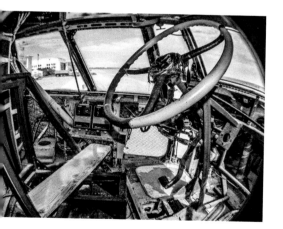

Above left: The Wendover Airforce Museum has stripped this plane of its innerworkings and opened it to the public. I used a wide-angle lens to capture this view inside the cockpit.

Above right: One of the few remaining windows inside the plane has been covered with the initials of countless visitors.

15

PARTNERS IN GRIME

E very place I go to is filled with adventure, frustration, discovery, and most importantly, friends. Constantly going on road trips, I have found few companions who can keep up with my lust for the unknown. My good friend and fellow photographer, Jamie Thissen Betts, is one of the few people who makes the cut. Whether keeping each other entertained for endless hours in the car or exploring a collapsing mine shaft, I know Jamie will have my back. While our photographic styles may differ, we share the same passion for exploration and history.

My wonderfully adventurous girlfriend, Lexi, is by my side whenever she is able. She's followed me into deep, unwelcoming mine shafts, crumbling buildings, and many other dangerous locations too numerous to count. Without her support and continued belief in my ideas, I would never have been able to produce this book.

These final few photos showcase Jamie and Lexi as I see them through my lens. May we forever be partners in grime.

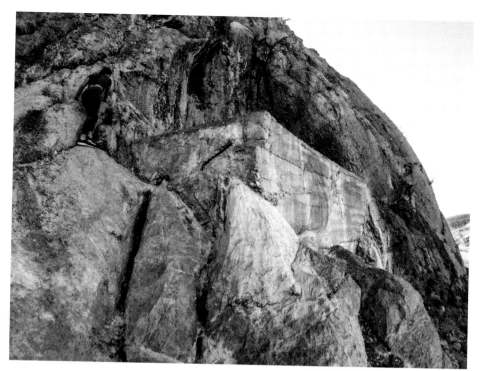

My partner in grime.

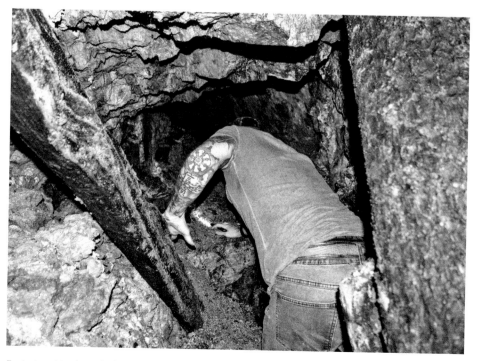

Exploring old mines shafts often requires a tight squeeze. Pictured here is my friend, Jamie, attempting to find a way through a collapsed mine tunnel.

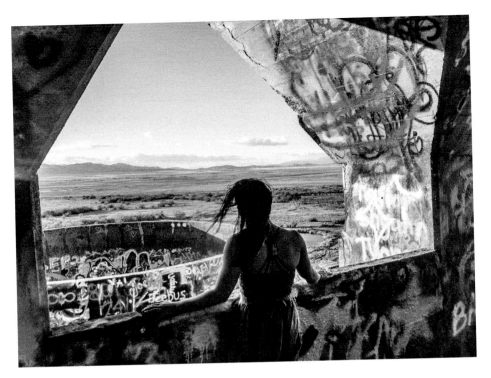

Beauty in the abandoned.

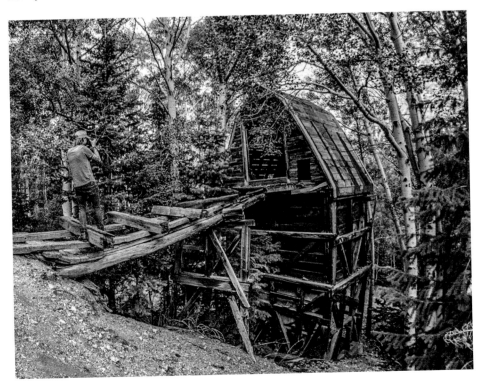

That bridge looks sturdy to me.

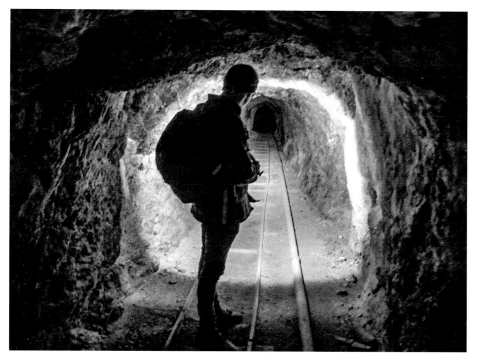

Light illuminates our path as we venture on into the darkness.

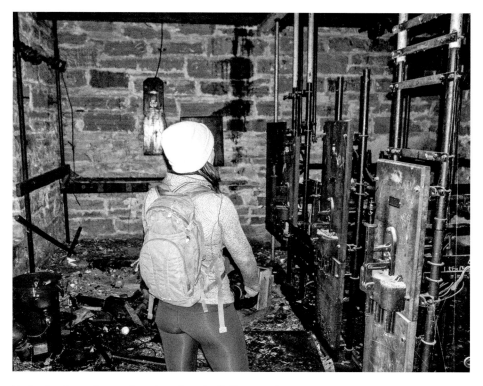

Exploration is much more fun when shared with those you love.

BIBLIOGRAPHY

Bauer – Utah Ghost Town." www.ghosttowns.com/states/ut/bauer.

Bushman, Gary. "History." *Marysvale, Utah*. www.marysvale.org/history.htm.

Jacob City, Utah. http://mtnmad.com/jacob-city-utah/.

"Eureka Utah, Historical Mining and Modern Day Ghost Town." *Utah Outdoor Activities*. https://www.utahoutdooractivities.com/eureka.html.

"EUREKA." *Utah History Encyclopedia*, https://www.uen.org/utah_history_encyclopedia/e/ EUREKA.shtml.

"GeoSights: Thistle Landslide Revisited, Utah County, Utah." *Utah Geological Survey*. https://geology.utah.gov/map-pub/survey-notes/geosights/thistle-landslide/.

"Historic Wendover Airfield Foundation - Wendover, Utah." *Historic Wendover Airfield Foundation - Wendover, Utah*. http://www.wendoverairbase.com/.

"History & Culture." *National Parks Service, U.S. Department of the Interior*. https://www.nps.gov/care/learn/historyculture/index.htm.

"History of Brighton and Solitude, Utah." *Silver Fork Lodge*. https://www.silverforklodge.com/ brighton-solitude-utah-history/.

"History of Moore's Old Pine Inn and Old West Town, Marysvale, Utah, USA." *Moore's Old Pine Inn*. www.oldpineinn.com/history.

Jones, Paul. "Jacob City: A Ghost of Utah's Past." *WildernessUSA*. 25 July 2016. http://wildernessusa.com/explore/articles/jacob-city-ghost-town/.

Liddell. "Thistle Ghost Town." *Atlas Obscura*. 15 July 2011. https://www.atlasobscura.com/ places/thistle-ghost-town.

"Mammoth Utah." *Western Mining History*. https://westernmininghistory.com/towns/utah/ mammoth/.

MillPictures.com. https://millpictures.com/mills.php?millid=1397&mill=Cottonwood Paper Mill / Deseret News Paper Mill / Granite Paper Mill.

"On the Temperature of Coal Mines." *Scientific American*. 21 Aug. 1869. https://www.scientificamerican.com/article/on-the-temperature-of-coal-mines/.

Ophir. https://www.ghosttowns.com/states/ut/ophir.html.

"Ophir Utah." *Western Mining History.* https://westernmininghistory.com/towns/utah/ophir1/.

"Remembering the Ghost Town of Bauer." *Bonneville Mariner.*
8 Sept. 2010. https://bonnevillemariner.wordpress.com/2010/09/08/remembering-the-ghost-town-of-bauer/.

"Senior Master Sergeant John T. Brinkman Service Club." *Historic Wendover Airfield Foundation.* http://www.wendoverairbase.com/restoration_service_club.

"Silver King Mine." *Western Mining History.* https://westernmininghistory.com/mine_detail/10011492/.

Strack, Don. "Silver King Coalition Mines Co." *UtahRails.net.* 25 June 2015.
http://utahrails.net/mining/silver-king-coalition.php.

"Swett Ranch Historical Homestead." *USDA Forest Service.* https://www.fs.usda.gov/recarea/ashley/recarea/?recid=72365.

The Inflation Calculator, https://westegg.com/inflation/infl.cgi.

"The Thistle Mudslide." *Omeka RSS* https://www.utahhumanities.org/stories/items/show/94.

"WASHINGTON COUNTY HISTORICAL SOCIETY." *Modena, Utah.* http://wchsutah.org/geography/modena.php.

"Wendover Air Force Base (U.S. National Park Service)." *National Parks Service.*
https://www.nps.gov/articles/wendover-air-force-base.htm.

Wiersdorf, G. William. *History of Modena, Utah.* https://onlineutah.us/modenahistory.shtml.

YouTube, YouTube, https://www.youtube.com/watch?v=2dbHIRLJU2o&feature=emb_title.

ABOUT THE AUTHOR

NICK BAGLEY is an abandoned building explorer who spends his free time researching and photographing abandoned locations all over the state of Utah. He is fascinated with the dark and dingy world that is often ignored by those who are entangled within the hustle and bustle of daily life. A full-time scientific photographer, he spends every spare moment he has researching and photographing places that seem to have been lost to time. Always up for an adventure, he never shies away from a rotting, derelict structure or a collapsing mine shaft. Nick takes readers on an exciting photographic tour of the abandoned world, granting them a first-hand look into the often grimy past that is *Abandoned Utah*.

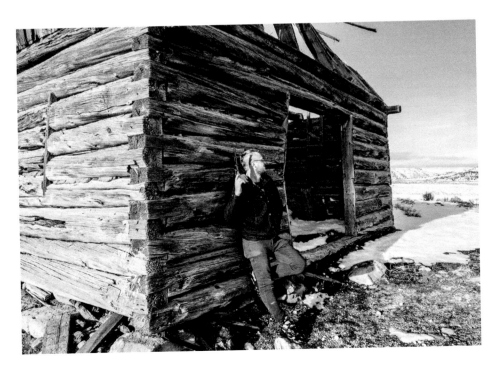